THE ACTING COACH APPROACH

# 48 Monologues
# for Kids
## and How to
## Master Them

## by Jon Emm

# CONTENTS continued

# Introduction

ongratulations! You have opened the book that is going to help you become the master of the mysterious world of the monologue. Not only will you find forty-eight fantastic monologues to choose from, but you will also find all the tools you need to perform them brilliantly. This is The Acting Coach Approach. Consider it the teacher's edition to learning monologues. I will show you how take words written on a page and turn them into a wonderful life experience full of rich characters and magical settings. What will be expected of you? It's simple: I want you to be brilliant, and all that takes is focus, dedication, and imagination. I will assist you every step of the way so you will understand the material and be able to perform your monologue the very best you can. What you will learn here is going to make doing a monologue so much easier and so much fun.

As actors, we need material to practice with, and it can be very time consuming to find a monologue in a play or in a script. I decided to write this collection of monologues to save you time. You no longer have to go through an entire script to find just the right piece. The challenge with most books like this is that when you choose a monologue, you don't have the character's backstory. I understand. That is why I designed this book with questions to help you fill in those blanks for yourself with ease. You will also have a really fun time doing it.

I want you to do something with me. Read the following two sentences to yourself: "I got a new bicycle. Let's ride to the fair!" Simple enough, right? Now let's paint a picture together. Let your imagination take over. Shake out your shoulders and really relax. Pause whenever you want to. Ready? Okay. Now read it again out loud: "I got a new bicycle. Let's ride to the fair!"

*I want you to picture a brand new shiny bike. It's yours. It's the one you wanted. Picture it. What color is it? Your friends are all on their bikes. They love your new bike. The looks on their faces, the way they are just staring at your bike—it makes you smile. You and your friends take off down the road, the country road you live on. You dodge around mud puddles and potholes. You are all laughing, swerving in and out of each other, racing. Can you feel it? The warm summer breeze blows on your face. The sun is beautiful in the bright-blue sky. You can smell fresh-cut grass.*

*Way up ahead you can see the Ferris wheel spinning, and you hear children screaming on the roller coaster. Can you hear them way off in the distance? You peddle as fast as you can to get there. You can't wait! You want to ride all the rides, and you want to win a prize. What games will you play? You race into the fairgrounds. You and your friends all jump off your bikes, and you quickly lock yours with your brand new lock. You remember the combination: 6-8-2-7. Locked. You take one last look at your bike to make sure it is safe, and then you sprint into the crowd.*

*There are so many people. Everyone is smiling and laughing. You can smell popcorn. There are snow cones and cotton candy, and you can hear bells and horns. You just stop and look around. You are so happy right now. And all the while you know that when you are all through here, you still get to ride your brand new bike, with all your friends, all the way back home.*

We just took two small sentences—"I got a new bicycle. Let's ride to the fair!"— and we created an entire afternoon. That is the magic of imagination. You don't have to live in the country or have a new bike or like to go to the fair. Heck, you don't even have to have any friends! Your imagination will create your entire world for you. All you have to do is allow yourself to imagine.

Each monologue in this book is accompanied by a set of questions for you, the actor, to answer. These are not tests. There are no right or wrong answers. The questions are there for one simple reason: to take you from seeing words on a page to living a real experience—just like we did with the bicycle. The questions are not difficult. In fact, if you find yourself really struggling, you may be on the wrong track. Don't be afraid to start over if you get stuck. It won't take long. I promise you that the more you work with the questions, the easier answering them will become and the easier it will be to memorize the monologue and perform it properly. Very soon, because you are using The Acting Coach Approach, people will watch you closely as you perform. They will want to know what it is that makes you such an interesting actor.

I've been fine-tuning The Acting Coach Approach with professional actress and founder of the Hollywood Theatre Lab Lana Young for many years now. In fact, all of her students have performed my monologues and scripts, and some have signed with agents or booked films using them. Lana is a great example of an actress laser focused on her acting dreams and goals, and she finds joy in sharing her enthusiasm and ongoing experience with her students. She prepares many children for auditions, and her results are fantastic, so it just seemed right to ask her to write the bonus section: Nailing the Audition.

One more thing I want you to know before we get started: Actors are not all beautiful people. They do not all have perfect hair and perfect teeth and sculptured bodies. They do not all have fantastic voices, and they cannot all dance and sing. Quite frankly, a large percentage of actors look just like you and me. But the one thing they do all have in common is a willingness to do the hard work. The great actors have been doing this hard work for years, and because of that, they make it look easy. Don't be fooled. It is not easy. But you have chosen The Acting Coach Approach. You have found the secret key that will unlock your imagination and help you grow as an actor. Follow the directions in this book. It will help you tremendously. Have fun, do the work, and break a leg!

# Practice Monologue: Roller Coaster

**A**s actors, we must memorize. However, we do not want to just memorize words on a page and recite them back. That is not acting, and it's boring to watch. Answering a few questions about your character and the scene will help you experience it, to make it something you can actually feel. Plus, it will make the words much easier to remember. Why? Because you will remember images instead of just words on a page. Remember the bicycle from the introduction? We turned two sentences into an entire afternoon.

{
**REMEMBER THIS LITTLE RULE:**
*If there is a line from a monologue that you just can't seem to remember, it is probably because you do not have a strong image in your head for it.*
}

Every monologue in this book is accompanied by a series of questions just like this practice monologue. The questions will help you trigger your imagination and build a life around the character who is speaking. Well-trained actors ask themselves these questions every time they approach a monologue or a scene, but they make the questions up for themselves. Those actors have learned what to ask in order to give depth to the characters they play, and you will too. With **The Acting Coach Approach**, you will learn what questions to ask yourself and how to answer those questions. Together we will open your imagination and create great characters.

The characters you create with the help of these questions will be real and much more interesting to watch. My hope is that you will not only find the questions fun to answer but that you will learn to ask yourself these questions with every monologue and every scene you do for the rest of your acting life.

Now let's use **The Acting Coach Approach** to learn how to perform a monologue. Follow the directions and complete the steps in order. First, you will need a pen and some paper. If you ever come across a word that you do not know, look it up. It's a great way to learn. If you find that you are struggling with a question on any monologue in the book, come back to this practice monologue and review how we do it here.

 **READ** the monologue silently to yourself. Always read it to yourself first. If you begin by reading aloud, you may hear it incorrectly and decide you don't like it before you have done the proper work on it.

**7**

 **READ** the monologue **AGAIN**—this time out loud.

 **ANALYZE** the monologue, searching for clues about your character in the punctuation, grammar, and stage directions.

 Read and **THINK** about the *challenge*.

 **ANSWER** the questions.

You may find that it is still hard to memorize lines or that there are certain questions that are difficult to answer. If that happens, take a break, but keep at it. Take a nap, take your dog for a walk, or call a friend on the phone. Then come back to your work. Soon it will all click. You will have a breakthrough, and you will grow as an actor. You are learning. Enjoy the journey.

Let's start with **step one:** Read this monologue to yourself. ————————
**DO NOT ANSWER THE QUESTIONS YET.**
When you are finished reading it, turn to the next page.

# → Roller Coaster

## (Boy or Girl)[1]

Okay, like, the guy working this thing looked like he was … he wicked scared us. Especially Sam. Sam was like, "No way! He's gonna kill us!"
We were all, "Chicken! BAWK BAWK! Chicken Sam!" Sam *is* kind of a chicken.

So I climbed onto this rickety old roller coaster. I'm used to the new ones, you know—super fast with corkscrews and loops and whatever. But this thing, it looks like a shipwreck, just old and cruddy. This other friend—you don't know him—he yells, "Boy, could I use a corkscrew!" just trying to be funny.

This scary guy just goes, "Ain't no need for no corkscrew." and locks us in. He never even looked at us. My friend looks at me like, "Oh my gosh! He's a maniac!" Then, the guy grabs onto this big bar, this lever thing, and he pushes it (*demonstrate this*) and he gives us this weird smile, like … like he was sending us to our doom.

We kinda jerked forward, and the whole thing was, like, knocking and rocking and bucking. All of a sudden, *zoom!* We took off! This is the fastest, scariest roller coaster in the world! I was screaming my head off. I couldn't even breathe! My friend, the one you don't know, was actually crying when we got off. Crying. (*Pause.*) You've got to try it when you go there. It's over by the Wheel of Death. Don't go on that, though. It's really dumb.

{ **CHALLENGE:** You must be a good storyteller. There are lots of pictures that your audience needs to see, and showing them those pictures is your job. Be big and animated. You also have to change your voice when you imitate someone. Talk clearly. Get excited, but do not talk too fast. This should be fun! }

---

[1] This practice monologue is written to be performed by anyone, but some monologues in this book are specifically for a boy or a girl. While reading, you may find that you are drawn to a monologue that is written for the opposite gender, and that is okay. You can change a name or a word or two of the monologue so that it suits you.

**1.** What is this monologue about?

**2.** Who are you talking to?

**3.** Where are you?

**4.** What was your moment before? What happened just before you started speaking these words?

**5.** What do you want? How are you going to get it?

**6.** Describe the roller coaster—all of it: its design, what it's made out of, your seat, and so on. Do the same for the Wheel of Death.

**7.** Who is Sam? Describe him or her.

**8.** Describe the maniac guy. What is he wearing? What is his hair like? His eyes? Be specific. The more clearly you see him, the more your audience will believe you.

**9.** Is it unusual for your friend to cry? When was the last time you saw him or her cry?

**10.** What did you do immediately after getting off the roller coaster?

**11.** Are there any more questions that you can ask yourself?

**12.** Write an autobiography for this character. Build your character a life.

**13.** Remember the magic "if": What would *you* do if you were in this situation?

**WRITE OUT** all of your answers and use lots of details. You should enjoy it, and it will get you closer to the truth of the scene.

**STEP 2** Read the monologue again, this time out loud. DO NOT ANSWER THE QUESTIONS YET. We will answer them together. When you have read it aloud, come back to this page for step three.

**STEP 3** Let's look at the monologue together. There will be a lot of clues in there to figure out who this character is. Approach a monologue this way each time, and you will be great.

# Analyzing the Monologue

**PUNCTUATION.** You must notice and obey the punctuation because it tells you how fast or how slow to go. We all talk and behave at different speeds. Some talk fast; others talk slow. Some people are nervous and jittery; others are calm. There are many clues in the punctuation.

▶ **Commas and Periods (, .)** In this monologue, there are lots of commas and short sentences. What does that tell you about the character? Maybe the character is excited. Or scared. Or nervous. Or confused. Maybe he/she's a combination of all of

them. In "Roller Coaster," the character seems very excited, right? Ask yourself, "When do I talk in short, choppy sentences?" How does it make you feel to read sentences that are punctuated like that? Can you feel yourself getting excited? Nervous? If you are someone who is usually very calm, you should feel different when you read sentences like these.

▶ **The Exclamation Mark (!)** Whenever you are given an exclamation mark, exclaim! Shout! The writer is telling you to exclaim, so do it! Ask yourself why the writer is telling you to exclaim, but don't fight it. Just do it!

▶ **Quotation Marks (" ")** When you quote someone in a monologue, that means that you are using their voice. You need to change your voice. This is a great opportunity to give your audience a clear picture of who you are imitating. Look at the quoted lines in "Roller Coaster": Sam says, *"No way! He's gonna kill us!"* This is your chance to really make Sam sound scared. Use a high-pitched voice, a whiny voice, or take another approach. Make him stutter: "N-n-n-no w-w-w-way! He's gonna k-k-k-kill us!" Now we get a good picture of Sam. And because you are imitating him, you can imitate how he looks, too. Make him scared! Bug your eyes. Make him shaky. Is he ready to run off? He is your character. Use your imagination. He is your character to create as you wish.

Also in "Roller Coaster," as a group you all yelled, *"Chicken! BAWK BAWK! Chicken Sam!"* Here you have both exclamation and quotation marks, so you need to really get into that line. You also quote the scary guy with the lever: *"Ain't no need for no corkscrew."* This line gives you a great opportunity to create a funny, scary character for your audience. You can make his face. You can mess up your hair, hunch your back, and squint your eyes. Do whatever you want to make sure your audience sees this weird, scary guy. Quotation marks are a great opportunity for actors to really act!

▶ **Ellipsis (...)** An ellipsis can have different meanings. Sometimes it means someone else is talking, which you'll see when your character is on the phone. This means you are listening. But in this monologue, the ellipsis means that you are hesitating. Look at the first line:

*"Okay, like, the guy working this thing looked like he was ... he wicked scared us."*

This ellipsis signals you are changing your thought right in the middle of the sentence. Why? Maybe you realized that it would take too long to describe the guy, so you changed your mind and just said he scared you. Or maybe you just don't really want to remember him. People change their minds all the time when they speak. In this case, you just need to hesitate, change a bit, and continue.

For example, let's say you walk into your house. You are very late. You were going to be on time, but a million unbelievable things happened between the time you left your friend's house and when you got home. And now you are late. By the look on your mom's face, you know she was worried and you are in big trouble.

She shouts, "WHERE WERE YOU?"

You respond, "You won't believe it. I was over ... never mind. Am I grounded?"

You began to tell her, but you realized in a split second that she wasn't going to believe you, and it didn't matter anyway because you were late. So you changed your mind about saying it. Begin, hesitate, change—that is how you use the ellipsis.

▶ **Question Mark (?)** It's simple: Really ask a question. Don't ever ignore the question mark.

**INSTRUCTION/DIRECTION.** When the writer gives you a specific instruction, he or she is telling you, directing you, how to do a particular thing at a particular time. Unless your teacher tells you differently, always follow these instructions. They are there for a reason.

▶ **(sit), (stand), or (exit):** When your writer tells you to move at a specific time, your job is to figure out why. Make sure the instruction makes sense to you. For example, if you are telling someone you love them, but your direction says (*exit*), you need to ask yourself, "Why am I leaving when I just told someone I love them?" Well, maybe you are really shy. Maybe you have never told anybody "I love you" before and you are scared of the response you might get. Or maybe you are lying; maybe one of your friends bet you ten bucks that you couldn't go tell this person you love them. You just have to make it make sense to you in that situation.

▶ **(start crying):** Directions that tell you how to feel are very helpful. In this case, you should be sad. Be sure that the way you are saying the monologue is leading up to tears.

▶ **(pause), (long pause),** or **(very long pause):** You must always fill these pauses with thoughts. You are never just there with an empty head—not as a person, not as an actor. Always ask, "Why am I pausing?" There is a pause in "Roller Coaster" in the third to last sentence:

*"My friend—the one you don't know—was actually crying when we got off. Crying. (Pause.) You've got to try it when you go there."*

So why the pause? Can you think of a reason? What about this: What if *you* were actually the one who was crying? Maybe the ride was so scary that it made you cry, but you said that your friend was the one crying. You lied, and it made you pause. Or maybe you are simply thinking about how terrifying this ride really was, so you take a moment and relive the ride. Fill your pauses with thoughts. Never pretend to think. Really think!

**GRAMMAR.** The way the writer uses words can let you in on some good secrets. If the grammar is really bad, maybe the character is not well educated. Or maybe the character does not speak English well. If the character says "like" often, maybe, like, you know, like, the character is, like, a little immature. Or maybe he or she is nervous. Chances are good that the character does not speak just like you do. Maybe the character lives in New York City, or she may be from the South, or maybe he's a surfer dude. All three of those characters would have different accents. Sometimes the writer will write that in. Just have fun and embrace the differences between you and your character.

**ITALICS.** When writers use *italics*, it means they want you to emphasize that particular word or phrase. For example: "How did *you* get here?" is different from "How did you *get* here?" The first is specific; they want to know about *you*—how *you* got there. The second one is asking *by what means* you got here. A car? A train? Did you walk? Did someone drop you off? See the difference? In "Roller Coaster," it says Sam *is* kind of a chicken. The character agrees, so we emphasize *is*.

**CAPITAL LETTERS.** If something is written in capital letters, the writer wants you to SHOUT! The writer may also give you instruction: (*shout*). Both mean the same thing, so shout!

## The Challenge

**STEP 4** is to read the challenge. When you have read the challenge for "Roller Coaster," come back here to continue.

Every monologue in this book tells you what your biggest challenge will be, because when it comes to acting, challenges are awesome. Bring it on, right? The challenge for "Roller Coaster" says that you must be a good storyteller. Maybe you don't consider yourself a good storyteller, but that's all the more reason to take on this monologue. This is practice. This is where you learn.

This monologue offers great opportunities to be larger than life. You get to be big and animated, and you get to imitate people. What a blast! Observe your friends and the people around you. Watch people who are really expressive when they speak, and you'll notice they use their hands and their faces to really express. Imitate them. That is what this monologue is asking you to do.

It also tells you not to go too fast. Many children talk too fast, so you need to focus on slowing down. Form your words in your mouth. Take the monologue one word at a time, and emphasize each of the words. This will slow you down and make you sound out everything, and it is a great lesson for any speech you perform in life. If you cannot sound out a word properly, your audience will not understand you. This approach will also help you to memorize the piece.

Another part of the challenge is to have fun. I cannot emphasize this enough. You are going to spend a good amount of time with these characters and the imaginary world that you create, and you should have a good time. If you find that the world you are creating for yourself is not fun, then start over again. You have the power to change everything. You also have the power to go on to a different monologue. Challenge yourself. You will be a better actor if you do.

## Answering the Questions

**STEP 5** Now let's move on to **step five** and answer the questions. Remember, you cannot answer them wrong. You are using your imagination.

**1. WHAT IS THIS MONOLOGUE ABOUT?** This seems like an easy enough question, right? Answer it concisely. Don't go into a long explanation. Be as specific as you can.

**ANSWER:** This monologue is about a bunch of kids who go to an amusement park and ride a really scary roller coaster. They thought it was slow and clunky, but it ended up scaring the wits out of them.

From here on out, I used my own imagination to answer the questions. Aside from this first question, I do not expect you to answer the questions the same way I did. These are only sample answers meant to inspire you to really dig into the questions in your own way.

As you go on to the rest of the questions, begin to talk in the first person (I, me, we): *I* was riding a roller coaster with *my* friends. This is very important because you are no longer looking in at something happening; you are now a part of it.

**2. WHO ARE YOU TALKING TO?** Who you are talking to can determine a lot. You don't speak the same way to a police officer as you do to your little sister.

For "Roller Coaster," let's say that you are talking to a parent. You may be a little less animated than you would be if you were talking to one of your friends, right? But you say in the monologue, *"You don't know him"* when you mention one of your friends who was with you. So whomever you're talking to does not know one of your friends.

Practice the monologue as if you are saying it to an old person. Then say it to a youngster. Then try it with a friend or a cousin from another town. Which feels best? Are you trying to impress someone? Use your imagination. Who you are speaking to will make a big difference in how you say it. You can use a real person or make the person up. It is up to you.

**SAMPLE ANSWER:** I am talking to my friend, Sylvia. She is sick and can't play with us right now.

Do you see what I did? I made up a sick friend. This explains why she was not with us. She is a captive audience while she is stuck in her bed, and she will really appreciate the roller-coaster story because she cannot play right now. Choosing someone who is ill as my audience allows me to be very animated and excited because she can't go out and have fun right now and would probably be glad to hear a good story.

**3. WHERE ARE YOU?** Once again, this will make a big difference in how you say the monologue. For instance, what if you were in the library? Try saying it in a hushed voice. As you try to tell the story, maybe the mean librarian is staring over at you. Try it as though you are talking to your mom while she is busy vacuuming the carpet. You need to talk loudly and follow her as she goes back and forth and back and forth. Now you're getting funny!

But I already chose a sick friend, right? How sick is she? Is she in the hospital? Why or why not? You need to describe where you are in detail because this will help make you aware of your surroundings while you are actually on an empty stage. It is very important to fill in the empty space around you, even when it is all in your head.

**SAMPLE ANSWER:** I am in my friend Sylvia's hospital room. She has been here awhile, so there are some pictures on her wall. Her little brother drew her a giraffe because that is her favorite animal. It is right above her bed. She also has a picture of Justin Bieber. Whatever. She has some cards that people have given her over on a little table with wheels. And she has lots of flowers. I see the flowers that I brought her last time I was here. I'm glad they are still alive. Sylvia has one of those beds that sits up. It is so awesome. Her roommate went home a couple days ago, so she has her own room

now. It's big. The floor is so shiny. She doesn't have to close that curtain that goes all the way around her bed. She has a plastic bag next to her bed with some stuff in it and a tube that goes into her arm. It really seems like it would hurt, but she says it doesn't. And she has her own TV. That is really cool.

Notice the life we are building. None of this is in the monologue, but if it is in your head and you can see it clearly, your audience will see it too. Your audience may not know specifically who you are talking to, but they will know that you are talking to someone you really care about. Let your imaginary world appear in your head before you begin the monologue.

## 4. WHAT WAS YOUR MOMENT BEFORE? WHAT HAPPENED JUST BEFORE YOU STARTED SPEAKING THESE WORDS? You must understand that your life—your character's life—did not begin when you started this monologue. You were already alive. So what were you doing just before you began to speak? If you were running through the rain, then your monologue will be different than it would be if you just woke up, right? Use your imagination and come up with something interesting. We know that I am visiting my sick friend Sylvia in the hospital, but what happened just before? Let's be clever.

**4. SAMPLE ANSWER:** I was sitting outside my friend's room for the longest time. They were checking her blood pressure or something. I couldn't tell because the curtain was drawn. Finally, the nurses left. I waited outside her curtain. I was going to try to scare her. We always do that to each other. I pulled back the curtain and jumped in and yelled, "SURPRISE!" This old man just stared at me. He had a big beard. I was shocked! I walked backwards out of his room. When I got into the hallway, I realized I was on the wrong floor. I ran all the way to Sylvia's room. I told her the story of the old man with the beard. She was laughing so hard. Now I'm talking about the amusement park.

I'm sure you are starting to get the picture. Enjoy this part of the process. It is just you and your imagination.

## 5. WHAT DO YOU WANT? HOW ARE YOU GOING TO GET IT? What you want is also called your *objective*. Different teachers will call it different things. This question can be difficult to answer sometimes, but it is very important. It is what drives the scene. What you want—what your character wants—is sometimes hidden in the monologue or scene. It is not always easy to spot. If your monologue is about a child screaming that she wants an ice cream cone, then that objective is pretty clear: The child wants an ice cream cone and is going to scream until she gets one. But in "Roller Coaster," it is a little less obvious. The objective is not really clear.

We all have reasons for saying the things we say. For example, I am sure you know

someone who just seems to ramble on and on. You may say to yourself, "Why is he still talking about that? Who cares?" Let's look at that person's objective: What if he just really wants attention? Then getting attention is his objective. Or what if the person is in love with you and wants to get you to love her? Then getting you to love her is her objective. Or what if the person is terrified to go home and he keeps talking to you because he wants you to stay with him? Then his objective is to get you to stay with him. You see, even when what you are saying seems like nonsense, there is always a reason that you are saying it. Sometimes that reason is hard to see. Work on it. Listen when people talk to you. What is their objective? What are they doing to get it?

Sometimes the objective will appear when you answer the other questions, and that is what happens here with "Roller Coaster." We chose to tell this story of the amusement park to a friend who was sick in the hospital. Why? Because we wanted to cheer her up, right? That is the objective. We are going to accomplish our objective by really getting into all of the characters so we can paint an amazing picture for our friend Sylvia.

**5. SAMPLE ANSWER:** I want to cheer up my sick friend Sylvia. I will cheer her up by going to her hospital room and telling her a really funny story as big and animated as I can be.

## 6. DESCRIBE THE ROLLER COASTER—ALL OF IT: ITS DESIGN, WHAT IT'S MADE OUT OF, YOUR SEAT, AND SO ON. DO THE SAME FOR THE WHEEL OF DEATH.
Now we are into the really fun part: the description. This is when we get to be as creative as we can be. We get to create a roller coaster—and the Wheel of Death. Draw pictures of the rides. Can you? If you can draw pictures, I strongly suggest that you draw everything you can. Drawings make great images for you to remember.

- Describe the bar that is across your lap holding you in. Is it secure? Is it clean?
- What does the roller coaster smell like? Does it smell greasy and dirty?
- What are some of the sounds that the roller coaster makes?
- Describe the track that it is on. Think of how fast it goes. Do you go upside down at all?
- Did you have to pay, or did you pay one fee to ride all the rides? Did you have to hand the guy a ticket?
- Was your seat comfortable? Hard? Who were you sitting by? Were there people in front of you? Behind you?
- Were you screaming?
- How high off the ground were you?
- Do you remember anybody watching?
- How did you feel when you got off? Were you woozy?

Then go into detail about the Wheel of Death. We have no idea what it is, so this is your opportunity to invent a ride. Go for it. And you already said it was dumb, so you can't get it wrong. Just have a ride in your mind.

The more images that you can fill in for yourself, the more you will remember the story as an experience and the easier it will be to remember the monologue. It is that simple. Color a picture for yourself, and you'll bring your monologue to life for your audience.

**6. SAMPLE ANSWER:** The roller coaster looked like it was about 150 years old. It was made of wood, and it looked like it had been painted black by a child. The paint was all chipped, and there were a lot of scuff marks or something. We had to climb a hundred steps to get up to it. There were eight cars all tied together. They were really low, like we were sitting in very small convertibles. The cars were also black and painted poorly, but the inside of the car—my car, anyway—was red.

The cushion was hard and uncomfortable. I remember feeling like I was sitting in an old-fashioned diner. I had to step down into the car. Actually, I had to step right onto the seat! What's up with that? We actually brought this cruddy old bar across our own laps. It was very tight across our thighs.

I sat by my friend Bill, the one you don't know. I was on the inside. He's tall, so it made me feel stuck in there. Sam was right in front of us. He sat with Margaret, and in front of them was Trisha. She sat with someone we didn't know. Corey sat behind us with Brit. The roller coaster was totally full, and everyone was saying stuff like, "This is lousy!" and "We wanna be scared!" and stuff like that.

When the ride started, it literally jerked the whole platform that the maniac was standing on. He just looked at us. We went up this hill. It wasn't even very big, but when we came down the other side, it was like we entered another world. We were flying! It was so shaky and creaky. I swear that made it even scarier. I was constantly being thrown against Bill, and we were both laughing so hard. At least, I thought we were laughing. And the whole time—the *whole* time—I could hear Sam screaming for his mommy. At first it was his mommy. Then it was God. By the time this thing stopped, I was shaking. I could barely talk.

The Wheel of Death is so dumb. First of all, it's the first ride you come to. It's way out by the parking lot, practically. It looks so cool from outside. It's like this red wheel sort of laying on its side, and it has fire painted all over it. There's really loud music coming out of it, like death metal music, and there's this weird voice saying something the whole time, but none of us could tell what it was saying. I think it was supposed to be the Devil or something. It was really loud, and it was just dumb.

Then you climb inside, and it's so dark. Everything is lit with a black light inside, and it is so dusty and stinky. It smelled like musty old socks. There are cushions along

the wall, and you're supposed to just find a spot and stay there, but there's nothing to hold on to. We were all looking at each other like, "Okay, now what?"

So once you get against the wall, the door closes, and you can feel it lift off a little. We were all a little freaked because we couldn't hold on. Then they turn the music up so loud you can't even hear anybody. The wheel slowly starts to turn, and all these different lights start flashing, and you can see all these demons painted all over and stuff. It goes on forever. Then you slow back down and drop back to the start. It is awful. I felt like I went to hell. Maybe that was the idea.

**7. WHO IS SAM? DESCRIBE HIM OR HER.** When it comes to describing a person, you can really have a blast. You can use one of your own friends as Sam if that helps you. Maybe you know a friend who is scared of everything. Let that friend be your Sam. Or you could take bits and pieces of a few of your friends and create a new friend. Or you could go look through a magazine, find someone you think would be a perfect Sam, and then write about the person in the picture. Or, if you are really creative, you can completely and totally make Sam up.

● How does Sam talk? Make sure you can hear him or her.
● What is Sam wearing?
● Is Sam chubby? Skinny? Awkward? Brainy?
● Does Sam wear glasses? Have freckles?
● What does Sam's hair look like?
● Describe Sam's face.
● What was the last thing Sam was scared of?
● What other rides did Sam go on at the amusement park?
● Is Sam really funny?
● Is Sam really scared, or is Sam just trying to get attention?

When your monologue is talking about a person—like this one talks about Sam, the scary guy, and the other friend—it is very important that you have someone in mind when you talk about that person. If you don't, you will not connect to that part of the monologue, and your audience will not connect to you. It is also much more difficult to memorize the words when you do not have strong images to go with them. Do the work. It's worth it.

**7. SAMPLE ANSWER:** Sam has been one of my best friends since before kindergarten. He lives right down the road from me. He is really funny. He has always been the center of attention because he is always clowning around. He is never serious—or rather it's hard to ever take him seriously, even when he is, because he always has a half-smile on his face. He once got socked in school because this one guy thought he was laughing at him, but Sam just always looks like that. So does his brother.

Sam has red hair, and he has a lot of freckles on his cheeks. He used to have more. He is very pale and burns really easily in the sun. He's a little chubby, but it's more like he's just really soft. He always wears a tee shirt and shorts, no matter what.

He can't swim at all, which is just so weird. I love to go to his house because they always have Pringles. He gets to stay up really late, so I like that too. We just laugh so hard whenever we're together. Sam's awesome.

**8. DESCRIBE THE MANIAC GUY. WHAT IS HE WEARING? WHAT IS HIS HAIR LIKE? HIS EYES? BE SPECIFIC. THE MORE CLEARLY YOU SEE HIM, THE MORE YOUR AUDIENCE WILL BELIEVE YOU.** Once again, you are creating a person. Hopefully you don't know anyone as scary and weird as this guy. Let's just say that you do not know anyone like this. Where do you find him? Well, you go deep into your imagination. We have all seen scary movies, but let's find this person ourselves and make him up from scratch.

When you think of a creepy guy, what do you think of first? How about his eyes: What color are they? Are they bloodshot? Do they dart all around, or does he stare deeply at you? Is the skin around his eyes wrinkled from the sun? Are his eyes bulging, or are they set back in their sockets?

Then let's see his face. What color is he? Is he dirty? Does he have any scars? Tattoos? You said he was creepy, right? What made him creepy? What about his teeth? Are they crooked? Yellow? Is he missing some? Does he have any teeth at all? Are his lips chapped or cracked? Is his hair long or short? Stringy or wavy? Is he totally bald? Is his hair filthy?

What about his body? Is he skinny? Fat? Is he missing any fingers? Maybe he is missing his whole arm! Is he tall? Small? Muscular? What about his clothes? Is he dirty? Is his shirt ripped? Are his paints greasy? Is he wearing any sort of hat? How about a leather jacket? A tank top? Shorts and sneakers?

Creepy people come in all shapes and sizes. You have choices when you are using your own imagination. Perhaps this guy is one of those skinny, dirty guys with no teeth and stringy hair and piercing eyes. On the other hand, big, tattooed, muscular guys who could snap you in two are scary too. Or how about a pudgy guy with shorts and sneakers and a wicked laugh? It's your imagination. Have fun creating your own scary character.

**8. SAMPLE ANSWER:** This guy was just so weird. He had straight, short, thin brown hair, and it almost looked like it was painted onto his head. You could tell he combed it, but why bother? It was like he combed it and then flattened it to his head with his hands. His face was shaved, I think. Either that or he just doesn't grow hair on his face.

He was probably forty or so. He looked very skinny, and he had terrible tattoos on his arms—the kind that look like he did them himself. Maybe he just got out of prison. That's what he looked like. His eyes were so dark. He acted like we weren't even there until we were locked into the seat, and then he just stared at us. At me, at least. I was terrified of him.

**9. IS IT UNUSUAL FOR YOUR FRIEND TO CRY? WHEN WAS THE LAST TIME YOU SAW HIM OR HER CRY?** Why are you being asked this question? There must be a reason. Let's look at the monologue. It says:

*"My friend was actually crying when we got off. Crying.* (Pause.)*"*

Obviously, this is an important moment in the monologue because you repeated "crying" and then you paused. So let's explore it. Maybe you have never seen your friend cry before. Maybe you just realized that you had never seen this friend cry, and that caused you to pause. Maybe this is someone who you look up to, someone who you would least expect to cry. Or maybe you think back to a time when something bad happened to your friend that made him cry. "But he has been so brave ever since," you think. You pause when you realize he must still be sad, that maybe he isn't so brave after all. Answer the question for yourself. If you have never seen your friend cry, think of a situation where you would have cried but he didn't. Is that what you are remembering during the pause?

Even comedic monologues can have a moment that is not funny. It doesn't mean that you get dramatic in that moment; it means that you remembered something that isn't funny even when you were being funny. That adds another layer to your character. You create layers when you use your imagination and ask yourself these questions. Are you starting to get it?

**9. SAMPLE ANSWER:** When Bill's mother died, we were maybe six or seven years old. I didn't go to the funeral or anything like that, but I saw Bill at church like a week after. The priest said that the mass was for his mom, Mrs. Granderson. I remember feeling really funny. I don't know what it means to say a mass for someone, but it made me feel sad to think about her. I kept watching Bill and his brother and sister, and Mr. Granderson. But Bill never cried or anything. So when he cried on the roller coaster, it just seemed strange to me. I guess I thought Bill must never cry.

**10. WHAT DID YOU DO IMMEDIATELY AFTER GETTING OFF THE ROLLER COASTER?** You have now created a world around the amusement park and the roller coaster. But the story you are telling Sylvia, although the words have stopped, is still going. What if she were to ask, "Then what did you guys do?" Have an answer ready to that question. What did you do next? Did you get some cotton candy? If so, think

about that situation: How much was it? What color was it? Did it get on your fingers? Did your friends all get some too? Did you pick on your friend about crying on the roller coaster? How far a walk was it from the roller coaster to the cotton candy? What did the person who sold it to you look like? Is everybody still talking about the roller coaster? Keep thinking. Fill in all the spaces with thoughts, and you will be great.

When you tell a story from memory, the story does not end when you stop talking. Our minds do not work like that. We are too smart. Follow through with the thought. As an actor, you should think right up until you hear the audience clapping. Or, if you are on set or in class, you stop when you hear *CUT!* Or, if you are in an audition, you stop when you hear, "That was fabulous! You got the part!"

**10. SAMPLE ANSWER:** When we got off that roller coaster, we were laughing so hard. Bill was laughing now too. It drops you off on the back side of it, so there were no stairs, and we were actually kind of lost. We came around the side of it, and we all looked up to see if we could see the scary guy, but we couldn't.

Then Trish yells, "Oh my gosh, you guys! It's almost six o'clock!" We were all freaking out. Trish's mom was picking us up at 5:30, and she made us promise we would be on time because she had to go to work. We sprinted as fast as we could. We ran all the way past the stupid Wheel of Death. Everyone was trying to talk like the Devil while we ran. It was so funny.

Then we saw Trish's mom up by the road. She didn't want to come into the parking lot. We all piled into her little car. I think Trish apologized all the way home. They dropped me and Bill and Sam off at my house. Poor Margaret had to stay in the car for another five miles. It was so fun, though. We had a blast!

## 11. ARE THERE ANY MORE QUESTIONS THAT YOU CAN ASK YOURSELF?

You may find, after you have gone through and answered the questions that are given, that you have stumbled upon something for yourself that really needs answering. Excellent! Now you are thinking. If you can come up with more questions, then you are surely thinking hard about the monologue. What else could we ask about "Roller Coaster"?

**1.** What other rides are at the park? Are there any more you could invent with your imagination?

**2.** How did you get home from the amusement park?

**3.** What did Sylvia think of the story?

**4.** What did you do when you left her room?

**5.** How long will she be in the hospital?

None of the questions about Sylvia have anything to do with what is written in the monologue; they all came from the question, "Who are you talking to?" The harder you

think about the monologue and the longer you dwell in the imaginary world of your character, the more layers you will build, and the richer your character will be. You will also remember the piece much better.

**12. WRITE AN AUTOBIOGRAPHY FOR THIS CHARACTER. BUILD YOUR CHARACTER A LIFE.** While this isn't a question, building the autobiography is a very important step and should never be ignored. An autobiography is a biography of someone narrated by that person. It means you are writing about your own life. But this character isn't you, right? So you get to make up a whole new life. What an adventure!

Tell us who you are (as your character). How old are you? Do you have any brothers or sisters? Do you live in a nice home? Who are your friends? Do you have a dog or a cat? Where do you live? Do you go to school? Are you home-schooled, maybe? Do you play any sports or have hobbies? Are you right handed or left handed? Shy or outgoing? A good student or bad? Do you have a pool? Do you like to chew gum? Are you sensitive? Do you like yourself? What is your relationship like with your parents? Do you live in the country or the city? You can get as personal as you'd like. You are playing the character.

In "Roller Coaster," you say, *"Chicken! BAWK! BAWK! Chicken Sam!"* You yourself may never say that. You might think it is stupid and childish. But this character said it, right? So how do you justify that? Let's say the character is not as mature as you are. You know plenty of people who are more immature than you are, right? What makes them different? Do they watch different TV shows than you? Do they read different books? Is it possible they play video games all the time and don't read books at all? Is it possible they have no parents at home to watch over them because both parents are working two jobs to support them? What would you do if you never had parents around to discipline you? It is your job as an actor to create a character who would say and do everything that the character in the monologue says and does. You get to create an entirely new you with each and every monologue or scene you do. What an opportunity. Actors are so lucky!

**13. REMEMBER THE MAGIC "IF": WHAT WOULD YOU DO IF YOU WERE IN THIS SITUATION?** This is a very important question to ask yourself as an actor. It is a tool introduced by a master theater actor and director named Constantin Stanislavski. It is a very simple question. When you develop a character for a monologue or scene, you may find that the character is nothing like you. That can be fun, but it can also be challenging. Think: You know yourself better than you know anyone else in the world, so if your character is nothing like you, simply ask yourself, "What would *I* do in this particular situation?" You may not do what the character did, but this gives you a place to start. It will help you behave in a real way. You will be believable in a situation that you may never find yourself in.

**\* \* \***

**y**ou are always talking to someone during a monologue. You are not just speaking out into an auditorium or into a camera. As you practice, ask your mom or your dad or a friend to sit with you so you are talking to someone. Have *all* your friends be a part of your monologue. Do whatever it takes to make these words on a page into a real situation for you. Then, when your practice audience goes away and it is just you and the empty stage, you will know where to look to find them. You will know what their reactions are to what you are saying, and you will feel fantastic having them there with you. You are never alone so long as you have your imagination.

This may seem like a lot of work for one little monologue, and maybe it is. This is all part of the process. It isn't easy to become someone else, even for a brief moment. You must learn everything there is to know about the character you are playing if you want your characters to be dynamic and real. You can still be good without any training, but I want you to be all you can be. I want you to be *great*. Be strong, be brave, be humble. You are on your way.

# One-Minute Monologues for Boys or Girls

1MMs

# Electric Fence

I know you have played Wii before, but I'm telling you, this is totally different. My father *made* it. You know my father is an electrician, right? Well, before that he used to make video games out in California. So he made this game. It isn't even for sale yet! I haven't even tried it. (*Turn the game on.*) He left it out here on the table, so ... (*look around for Dad*) I guess that means we can try it. It's called Electric Fence. (*Wait.*)

There it is. Okay, it works like this: We are that sheep right there. See how I can move it left and right? I can also make it jump like this (*use the imaginary joystick*). Isn't that hilarious? Anyways, the object is to get the sheep to freedom. But it's really dangerous because there are wolves and snakes, and then once you get free, you don't want to get hit by a car. (*Begin to play.*) But the big thing is, see all those blue lines? That is the electric fence. And my dad said that if you, the sheep, touch the fence, you actually get a real—(*feel a huge shock in your hand*) AHHHHH! (*Trying to be calm*) Wow! That really ... you want to try it?

**CHALLENGE:** You kind of know you shouldn't play with the game yet, even though it was left out. So you are half-sneaking, but you are very excited at the same time. It's tricky. You also need to look like you are really playing a game. Take your time. Then, the biggie: You have to pretend to get a huge shock! Have a blast with this one!

**1.** What is this monologue about?
**2.** Who are you talking to?
Try it talking to a different person, too. Did it change? It should.
**3.** What was your moment before?
**4.** Where are you?
**5.** What do you want? How are you going to get it? (see pages 16-17)
**6.** Describe the game—especially the sheep. Practice holding the controls in your hands.
**7.** Describe the time your father told you about the game. Where does he work on it?
**8.** Have you been shocked in your life? What would that feel like magnified? Does it hurt? What does it feel like afterwards? Are you tingly?
**9.** Why do you want the other person to try it?
**10.** Would anyone buy this game, or is it a crazy idea?
Describe what your friends would think of a game that really hurts the players.
**11.** Are there any more questions that you can ask yourself?
**12.** Write an autobiography for this character. Build your character a life.
**13.** Remember the magic "if": What would *you* do if you were in this situation?

Write out all of your answers. Be specific. It will get you closer to the truth of the scene, and you will create a stronger character.

# THREE-WORD **PLAY**

I can't decide how I should say this line. Listen. (*Strike a strong pose.*) "I can see!

Or do you think it's better like this? (*Strike a weak pose.*) " I can see."

Did you hear the difference? See, we've been trapped in a mine for, like, days, and we finally get out. But I can't decide if I'm proud, like (*repeat the first pose*) "I can see!" or really relieved, but kind of tired and weak. (*Repeat the second pose*) "I can see." Is that too dramatic? (*Repeat the second pose again*) "I can see."

Or I could be really excited, like, "I CAN SEE!" Light! Food! Water! Clean clothes! Right? Or I could be sort of frustrated. Like, like maybe another miner said, "Hey, look! There's light!" Then I would say, "Yeah, I know. I can see." You know what I mean? It's tough. These three-word plays are so challenging.

**CHALLENGE:** To say a lot with a little. You must really strike your poses and change each time to make your audience truly understand what you are doing. Try it as though you are talking to a fellow student. Then try an adult—maybe a teacher. Maybe even try a grandparent. See which you like better. Take your time, and have fun.

**1.** What is this monologue about?

**2.** Who are you talking to?

**3.** What was your moment before?

**4.** Where are you?

**5.** What do you want? How are you going to get it? (see pages 16-17)

**6.** Describe the person who gave you this assignment.

**7.** Which pose feels the most correct to you? Is there any other way to say, "I can see"? Act out other ways.

**8.** Describe what it feels like to be trapped in a mine.

**9.** Who will you be performing this play for?

**10.** When it says, *"strike a weak pose,"* how does that make you feel?

**11.** Are there any more questions that you can ask yourself?

**12.** Write an autobiography for this character. Build your character a life.

**13.** Remember the magic "if": What would *you* do if you were in this situation?

Write out all of your answers. Be specific. It will get you closer to the truth of the scene, and you will create a stronger character.

# Eggs in a Basket

My grandmother was always saying, "Don't put all your eggs in one basket." So I thought that all this time my grandmother grew up on a farm. How else would she know not to do it? I pictured her running from the chicken coop with her dog chasing her and the chickens squawking and her little eggs all piled high, her little granny hat flapping in the breeze.

Then, the other night, my dog is sniffing around her leg, and Granny freaks out ... Well, as much as grannies *can* freak out. I went into the kitchen, and I asked my mother what was up with her. She tells me it's because the apartment building in New York City where Granny grew up couldn't have dogs, so she never got used to them. (*Pause.*)

Then, after I ask about the farm and the eggs, my mom tells me, "Granny? She hates eggs, and she wouldn't be caught dead on a farm." (*Pause.*) I don't even know this family.

**CHALLENGE:** To make your audience believe that you just discovered this huge fact that your grandmother grew up in an apartment in New York City and not on a farm. When you discover something it seems like you should have known already, it can be hard to make others believe you. Speak very clearly and not too fast. And you have to give Granny a little New York accent—not a lot, but some. Figure it out. All you need is a tiny bit, and it will be funny. You need a voice for your mother as well. Make sure you fill your pauses with thoughts. Your audience must see what you are thinking.

**1.** What is this monologue about?
**2.** Where are you?
**3.** Who are you talking to?
**4.** What do you want? How are you going to get it? (see pages 16-17)
**5.** What was your moment before? What happened just before you began to speak?
**6.** Think about Granny. How is her childhood different in your mind now that you know she grew up in a city instead of in the country?
**7.** Describe your dog.
**8.** Describe how Granny freaked out. Get on your feet and practice it.
**9.** What does the phrase "don't put all your eggs in one basket" mean? Give an example.
**10.** What was your mother doing when you went into the kitchen?
**11.** Are there any more questions that you can ask yourself?
**12.** Write an autobiography for this character. Build your character a life.
**13.** Remember the magic "if": What would *you* do if you were in this situation?

Write out all of your answers. Be specific. It will get you closer to the truth of the scene, and you will create a stronger character.

# Dad's Beard

My dad grew a beard. I don't even know when he did it. Last Sunday he looked a little scruffy, but I just thought it was because his friend from college was visiting and they stayed up really late. But his friend left Sunday night, and now Dad has, like, a *full-grown beard*. How? Does laughing really loud and not going to bed make your beard grow? (*Pause.*)

I can't decide if I like it or not. I think Mom feels the same way. It pricks when you touch it, and he just laughs. He always asks me to scratch it, and then he kicks his leg like our dog Deets. I used to love his face. I mean, his old face. I *mean* his before-the-beard face.

I can't even picture his before face right now. (*Pause.*) I've known his face for (*say your age*) years, and now I can't remember it (*short pause*). My memory is shot.

**CHALLENGE:** To only sort of complain. No audience likes to watch someone complain. You have to tell us about your dad's beard and whether you like it or not, but this monologue shouldn't sound like a big complaint. It will be funnier if you can convince your audience that you are thinking of this right now for the first time. *Use your pauses.* Decide whether you want to be really excited or you want to say it calmly. Excited is more of a complaint, so you have to be careful not to say everything the same way. Saying it calmly will make you sound more disappointed instead of complaining. It is your choice. Have fun!

**1.** What is this monologue about?

**2.** Where are you?

**3.** Who are you talking to?

**4.** What was your moment before?

**5.** What do you want? How are you going to get it? (see pages 16-17)

**6.** Describe your dad's beard (color, shape, roughness). Can you draw it? What does everyone else think of it? Give everyone in your character's family an opinion.

**7.** Who is your dad's friend from college? Does he come around much? Describe him.

**8.** Describe Deets.

**9.** Where were your father and his friend when they were staying up late?

**10.** Who have you heard say that their memory is shot? Give an example.

**11.** Are there any more questions that you can ask yourself?

**12.** Write an autobiography for this character. Build your character a life.

**13.** Remember the magic "if": What would *you* do if you were in this situation?

Write out all of your answers. Be specific. It will get you closer to the truth of the scene, and you will create a stronger character.

# PIZZA CUPBOARD

(*Looking at the menu on a wall*) So okay, let me get one slice with … That says one slice is $1.75 and all extra toppings are 25 cents. So … they have pepperoni, which I hate. They have sausage, which I hate even more than pepperoni. They have ground beef. Ground beef on pizza? Seriously? Oh, and then they have specialty toppings over here.

Potato … potato? Artichoke hearts, broccoli, peas … PEAS?! Yuck! Is my mother back there somewhere? Peas … (*reading on*) Does that say crackers? Does that say *crackers?* They put crackers on pizza? What kind of crackers? Like *cracker* crackers? That says "crackers," right? Unbelievable.

So for … $2.25 I could get a slice with crackers, peas, and potatoes. Or I could go across the street to Burger Heaven and get a cheeseburger with french fries and ketchup. Let me think, let me think … see you later, Pizza Cupboard.

**CHALLENGE:** To find your peaks and valleys. There are places where you should get very excited, and then there are places where you have to come all the way back. It is very important that you do not stay in one place with your emotions. Go up, and then come back down. Speed up, then slow down. Use your pauses, take your time, and have a blast!

**1.** What is this monologue about?
**2.** Where are you? Be specific. Draw the restaurant if you can. Is it busy? Empty?
**3.** Who are you talking to? Are you sometimes talking to someone you are with and sometimes talking to the person behind the counter? Be specific.
**4.** What was your moment just before you began speaking? Were you in line? Did you just walk in?
**5.** What do you want? How are you going to get it? (see pages 16-17)
**6.** Describe the person behind the counter.
**7.** What kind of street is it that you would have to cross?
**8.** How much money do you have? Is it in dollars, quarters, or dimes? Be specific.
**9.** Why is this place called Pizza Cupboard?
**10.** Are there any more questions that you can ask yourself?
**11.** Write an autobiography for this character. Build your character a life.
**12.** Remember the magic "if": What would *you* do if you were in this situation?

Write out all of your answers. Be specific. It will get you closer to the truth of the scene, and you will create a stronger character.

# Swim Team

You seriously are going to go? Really? I can't do it! I swear, I can't. I know we have been practicing like crazy, and I know it's not that big a deal, but I am just so nervous! Like, I can understand swimming practice. Get in, swim back and forth and back and forth and kick with that stupid board. But an *actual* swim meet? I can't do it! I will sink like a rock. I'll get a cramp. I'll throw up. I will! Right in the water.

I know, I know. You don't even have to say it. Why did I join swim team, right? Because I thought it would make me a better swimmer, which it has, I suppose. *And* I hate basketball. I don't know. Because (*pause*) you did, I guess. But you're really good, and you usually win. I'm just … I just … Oh, all right. But promise not to laugh when I come in last!

**CHALLENGE:** To play a weak character. There is nothing *actually* wrong with you, but you lack confidence and you are scared. It can be tricky to play a weaker character when you are not weak yourself. You are hoping to make your friend understand, so you are pleading. Make sure you don't stay on the same note the whole time. Change your voice now and then. Use your pauses. Make your audience understand your challenge rather than think you are just a wimp. Don't talk too fast!

**1.** What is this monologue about?
**2.** Who are you talking to?
**3.** Where are you?
**4.** What do you want? How are you going to get it? (see pages 16-17)
**5.** What was your moment before?
**6.** Describe one of your swim practices. When are they? What do you do? What do you like? What do you dislike? Do you try hard, or do you just play around?
**7.** Why do you hate basketball?
**8.** Tell us about your swimming coach.
**9.** Where is your pool? How do you get to practice? Describe the locker room.
**10.** What other sports do you play?
**11.** Are there any more questions that you can ask yourself?
**12.** Write an autobiography for this character. Build your character a life.
**13.** Remember the magic "if": What would *you* do if you were in this situation?

Write out all of your answers. Be specific. It will get you closer to the truth of the scene, and you will create a stronger character.

# Jt Jsn't Easy

The trouble with always being right is that people are always expecting you to be right. Which really shouldn't matter if you *are* always right, but sometimes … you just can't be 100 percent sure you're right. Right? There are a lot of tough decisions you have to make, and when a lot of people are counting on you, staring at you … (*pause*) I guess what I'm saying is, or trying to say, is it isn't easy being me. Seriously.

I'm the fastest one in my gym class, so everyone is always trying to pick me for their team. I'm the smartest, so everyone is always trying to copy my homework. *Trying* is the key word. And I'm the coolest … I shouldn't say that. People *think* I'm the coolest, so everybody wants to hang around with me. And I'm the leader because I always have the answer to every question. So, don't you think it's so weird that nobody told me where the party is tonight? Everybody must have just forgot to tell me. … It's so weird.

**CHALLENGE:** To be a convincing bragger. The better you can brag about yourself, the funnier your scene will be. Be confident and proud, and take yourself *way too* seriously. This scene gives you the opportunity to make fun of all the braggers you have known. And if you really are a bragger, maybe this will show you what you sound like to others. Have fun!

**1.** What is this monologue about?
**2.** Who are you talking to?
**3.** What was your moment before? Why are you speaking these words?
**4.** Where are you?
**5.** What do you want? How are you going to get it? (see pages 16-17)
**6.** Who are your friends? Write about three of them. What kind of people do you hang around with who would make you think you are so awesome?
**7.** Do you know anyone like this character? Describe them.
**8.** Why didn't anybody tell you about the party?
**9.** Do you (the character) like yourself? Or are you just very insecure? Think about it. It doesn't change what you say, but it might change the way you think about what you say.
**10.** How do you act when someone tries to copy your work?
**11.** Are there any more questions that you can ask yourself?
**12.** Write an autobiography for this character. Build your character a life.
**13.** Remember the magic "if": What would *you* do if you were in this situation?

Write out all of your answers. Be specific. It will get you closer to the truth of the scene, and you will create a stronger character.

# THE GARDEN

(*Walking through the garden*) That row there is lettuce. We planted two different kinds. One is Roman lettuce, and the other is like … *lettuce*-lettuce. We really have to watch for rabbits. I like rabbits, but my dad said one rabbit can ruin our whole garden. I told him we should just plant enough for the rabbit. Dad just shook his head.

(*Walking*) Oh, right there is carrots. They're underground. I saw Bugs Bunny once tunnel under the carrots and pull them down. Elmer Fudd was furious. I told my dad I'd keep an eye out for disappearing carrots. He said, "Fine, you do that."

(*Walking*) Right there, those are radishes. I hate radishes. I feed them to the dog under the table, but Smokey won't eat them either.

Over there is our tomatoes. My dad said they'll make my hair curly. (*Pause.*) But my mom loves tomatoes, and her hair is totally straight. Wait … so my mom must be feeding her tomatoes to Smokey under the table. Wait! Smokey is totally curly! I am so telling my dad.

**CHALLENGE:** To make sure the audience can see all the vegetables you see. Be very specific about where they are. Gardens are very organized. Take your time. Don't actually walk too far. You have to make us see the discovery when you realize that your mother must be feeding tomatoes to the dog. That needs to be a big realization and a big change.

**1.** What is this monologue about?
**2.** Who are you talking to?
**3.** What was your moment before?
**4.** What do you want? How are you going to get it? (see pages 16-17)
**5.** Describe the garden in detail. What else is in the garden? Bugs? Birds? Is it fenced in?
**6.** How will your mother react to you telling on her? Are you a tattle tail?
**7.** Describe your table that you feed the dog from. Have a very clear image.
**8.** Describe Smokey. Remember, your dog's fur is curly. Draw your dog.
**9.** What does your father wear when he is in the garden?
**10.** What do you have on your feet when you are in the garden? Be descriptive.
**11.** Are there any more questions that you can ask yourself?
**12.** Write an autobiography for this character. Build your character a life.
**13.** Remember the magic "if": What would *you* do if you were in this situation?

Write out all of your answers. Be specific. It will get you closer to the truth of the scene, and you will create a stronger character.

# The Hat

(*Holding a hat*) This is what is so cool about this hat. You can wear it all these different ways, and it just changes your attitude. Like, watch this … (*Put the hat on.*) If you wear it like this, right, it says I am just a normal person. I don't really do much to draw attention to myself. I'm cool enough to wear a hat, but that's about it.

Or I can wear it like this. (*Do something different with the hat.*) This says that I am sophisticated and together. I have a bit of an attitude. I might be a little cooler than you, but I'm still willing to talk with you and give you a chance. I hang with cool people.

Then, ready? (*Change the hat again.*) You can wear it like this. Do I even need to say it? I am so hip, so … suave. I will not talk to you in school because I am entirely too cool for school. If I was old enough to get a job, I would either be a movie star or a designer. I would walk like this (*walk*), and I would talk like this (*use an accent*): "Get me a coffee. And make it snappy!" (*Put the hat back to the first way.*) But for now, I just like it like this.

**CHALLENGE:** To be very physical with each attitude. Each attitude will make you behave differently—the way you stand, the way you hold your head, the way you pose, and so on. Make all the different attitudes real. Take your time. Use your imagination, and have fun.

**1.** What is this monologue about?
**2.** Who are you talking to?
**3.** What happened the moment before you started this monologue?
**4.** Where are you?
**5.** What do you want? How are you going to get it? (see pages 16-17)
**6.** Create a picture in your mind for each attitude. How does each attitude make you feel?
**6.** Look at yourself in the mirror. Create attitudes based on how you actually feel. Be playful, but real. It will be funnier.
**7.** Where did you get the hat? Take this opportunity to be creative.
**8.** Are there any more attitudes that you could bring to the hat?
**9.** Which attitude do you like best? Why?
**10.** Look at pictures of people who wear hats. Describe what it is that makes them cool.
**11.** Are there any more questions that you can ask yourself?
**12.** Write an autobiography for this character. Build your character a life.
**13.** Remember the magic "if": What would *you* do if you were in this situation?

Write out all of your answers. Be specific. It will get you closer to the truth of the scene, and you will create a stronger character.

# The Pact (dramatic)

"We will always be truthful, loyal, and faithful friends, forever in trust." That's what we said. You stood right on that spot and repeated it with me. And now you're … All I did was ask you if you were going to the party Saturday night, and you jump down my throat! What's wrong with that? Help me out here, Jen. I don't understand. (*Pause for change.*)

You are my best friend, Jenny. Obviously, something is bothering you. (*Pause.*) Really? You're just not … You have nothing to say? Don't you trust me anymore? What did I do? Please tell me.

Maybe … I know—why don't we go down by the creek to our safe spot? We can listen to the trickle. Maybe that squirrel will be there again. Maybe we can see that squirrel again. Remember that squirrel? Jenny?

**CHALLenge:** To not speak too fast. Best friends, especially when they are excited or upset, speak very fast to each other. You have to slow down so your audience can stay with you. And make sure that you change speeds at the pauses. You are trying different approaches to get your friend to open up. When actors try a different approach, they must change speed. Have fun, control yourself, and get to the bottom of it.

**1.** What is this monologue about?
**2.** What was your moment before?
**3.** Where are you?
**4.** What do you want? How are you going to get it? (see pages 16-17)
**5.** What is a pact? Have you ever made one yourself?
**6.** What does Jenny look like? Describe her perfectly. What she is wearing? How is her hair? Her eyes? Is she crying? Has this happened before?
**7.** Why is she your best friend? Why do you love her?
**8.** Where is the party? What kind of party is it? Who else will be there?
**9.** What do you think is bothering Jenny? Don't say that you don't know. Create a scene that would come right after this scene where Jenny tells you what is wrong.
**10.** Draw the creek and where exactly you go with Jenny. Describe the situation with the squirrel.
**11.** Are there any more questions that you can ask yourself?
**12.** Write an autobiography for this character. Build your character a life.
**13.** Remember the magic "if": What would *you* do if you were in this situation?

Write out all of your answers. Be specific. It will get you closer to the truth of the scene, and you will create a stronger character.

# Snowballs

Everybody was throwing them—Evelyn, Sasha, Brian ... I even think Tony threw one, but he'd never admit it because his father would ground him for the rest of his life. All I did was throw one little snowball. Honest—*one*. What are the chances that Mrs. Cordero would come around the corner?

We thought it was Kyle Shaver. I know we're not supposed to pick on Kyle, but Kyle hit Evelyn in the face with a snowball yesterday, and we wanted to get him back. We thought Mrs. Cordero was Kyle. I mean, why does he have the same coat and hat as Mrs. Cordero? Seriously, he's a kid and she's an old lady. Anyway, it was an honest mistake. Honestly. And I swear I never meant to scare her little Poochie Lou.

**CHALLENGE:** You did something wrong, and you have to convince us that it was not on purpose. You must act like you are in big trouble and this is your one chance to explain yourself. It is up to you to fill in the blanks from the time the incident happened until right now. Don't skip all those wonderful details in between.

**1.** What is this monologue about?
**2.** Who are you talking to? Be specific.
**3.** What was your moment before?
**4.** Where are you?
**5.** What do you want? How are you going to get it? (see pages 16-17)
**6.** Describe where you were when the incident occurred. Can you draw it? Was it cold?
**7.** Describe Mrs. Cordero. How did she act when you hit her with the snowball?
**8.** Describe Poochie Lou. Why was she (or he) scared?
**9.** Describe all the friends that you mentioned.
**10.** Who is Kyle Shaver? Why were you told not to pick on him?
**11.** Describe what happened when Kyle hit Evelyn with the snowball. What did you do?
**12.** Are there any more questions that you can ask yourself?
**13.** Write an autobiography for this character. Build your character a life.
**14.** Remember the magic "if": What would *you* do if you were in this situation?

Write out all of your answers. Be specific. It will get you closer to the truth of the scene, and you will create a stronger character.

# BIGFOOT

(*Out of breath*) I am totally serious, you guys! I think I saw Bigfoot! Don't laugh at me. I was crossing the creek down by the bridge. I was actually *on* the bridge at first, but I saw a bee ... Anyways, I started wading across the water by the bridge, and then I saw this big black snake, and I screamed! Then I realized it was just a stick, but I swear it looked exactly like a snake. So I climbed out of the water, and ... there he was. There *IT* was!

It was huge! It had a huge, hairy face and a big hunchback, and it was just staring at me. At first I thought it was just some big weird guy, but then it opened its mouth, and it had huge, scary teeth, and it started running toward me. I just ran as fast as I could to get here ... It was ... I was ... Have you guys seen anything like that?

**CHALLENGE:** To convince your audience that you saw Bigfoot. You are obviously scared of things (bees, snakes), but you want your friends to believe you. You are begging them to believe you. Make sure your audience hears every word. Don't get so excited that your audience cannot understand you, and don't talk too fast! It is up to you to decide whether your friends are listening to you carefully or if they are laughing at you. That will make a big difference in how you say this. Try both ways before deciding. Use all of your pauses. Remember, you are out of breath. That can be tricky.

**1.** What is this scene about?
**2.** Who are you talking to? How many people? Be specific about everyone.
**3.** Where are you? Describe it with details.
**4.** What do you want? How are you going to get it? (see pages 16-17)
**5.** Describe the bridge. How did you get from the bridge to the water? Describe the water you were wading across.
**6.** Why were you alone? Where were you before?
**7.** You are out of breath. Are you wet? Nervous? Are you still looking over your shoulder?
**7.** Draw your Bigfoot.
**8.** How did you all get to where you are? How far did you have to run from the water?
**9.** What do you want to do now?
**10.** What happened after you got back and asked if anyone saw anything? Picture a scenario. Maybe someone else saw Bigfoot, too. Maybe they all think you're crazy. Create a scene of your own.
**11.** Are there any more questions that you can ask yourself?
**12.** Write an autobiography for this character. Build your character a life.
**13.** Remember the magic "if": What would *you* do if you were in this situation?

Write out all of your answers. Be specific. It will get you closer to the truth of the scene, and you will create a stronger character.

# THE FLASHLIGHT

(*Shining a flashlight, moving carefully*) Where is everybody? … Hello? Are you in here? You guys, please! You better not be trying to scare me … Anybody? … If you can hear me, please answer … (*Stop and stand perfectly still.*) Emma? Milli? Brett?

HELP! (*Starting to really panic*) I mean it, you guys! I am starting to really freak out. I need you to answer me, PLEASE! … Hello? If you guys are doing this because I didn't share my Twix with you, I'm sorry. We have a whole bag at home. I'll bring the whole bag tomorrow. We have Doritos. Alan, you love Doritos. Remember, you ate all my Doritos on Thursday?

Anybody? Mom? Dad? I'm so scared. (*You're just about to cry when the lights come on and you realize it's a surprise party for you. Surprise!*) (*Shocked*) I hate all of you (*giggling*). You remembered my birthday. (*Smiling*) I hate all of you... I will never share anything. Ever!

**CHALLENGE:** To actually act scared. You need to carefully walk through the space, seeing only what the flashlight is pointing at. And you need to be shocked when the lights come on. You need to convince us that you were just surprised. Practice shining a flashlight and following the light beam. Then do it again without the light. Practice being in the dark and then having all the lights come on. Use a mirror to watch yourself. This can be very challenging, and it is also very active. Try it!

**1.** What is this monologue about?
**2.** Who are you talking to?
**3.** What was your moment before?
**4.** Where are you?
**5.** What do you want? How are you going to get it? (see pages 16-17)
**6.** How did they set up this surprise? Who was behind it?
**7.** What does the silence feel like? Are you scared of the dark?
**8.** Think of where the Twix bars and the Doritos are in your house. Describe it.
**9.** Describe exactly what you see when the lights come on.
**10.** What is the scariest thing you can think of seeing when the lights come on?
**11.** Are there any more questions that you can ask yourself?
**12.** Write an autobiography for this character. Build your character a life.
**13.** Remember the magic "if": What would *you* do if you were in this situation?

Write out all of your answers. Be specific. It will get you closer to the truth of the scene, and you will create a stronger character.

# BENNY (dramatic)

It wasn't like that at all! I can't believe you think … That's totally wrong. I'm sorry. I don't mean to sound like a jerk. Honestly. Really, though, I can't let you guys just think that we did it, that—that Chaz did it on purpose. We would never do anything to hurt Benny. We like him. *I* like him. We … we were only trying to scare him.

I know that's really mean and everything, but that is all we were trying to do. Chaz got this … We were at Carter's Gifts. They don't care if we're underage. The owner is blind. He wears … Anyway, Chaz got this … Well, you saw it—that gorilla mask. We just liked it. We weren't … We didn't have any plans to do anything or anything like that. (*Pause.*)

We were driving past Cordell Drive, and we saw Mrs. Paulette waiting there. So we knew that meant Benny was in class over at the Center. We hid in the woods right there … I swear, we would never hurt him intentionally. We were only trying to scare him.

**CHALLENGE:** You are obviously in trouble, so you are nervous. When we are nervous, we change thoughts very quickly. We also change the speed at which we are talking. Find the moments where you change, and make it very clear that the thought has changed. Make sure your audience follows you. Figure it out. Follow your punctuation. It can be tricky, but you can do it.

**1.** What is this monologue about?
**2.** Who are you talking to? Be very specific.
**3.** What was your moment before?
**4.** Where are you? Be specific.
**5.** What do you want? How are you going to get it? (see pages 16-17)
**6.** Describe Chaz. Does he drive? Is he cool? Do your parents like him? Describe your relationship with Chaz, and be very specific.
**7.** Describe Mrs. Paulette. Why does she wait for Benny on the corner?
**8.** What is "the Center"?
**9.** Describe Benny. How do you know him? If there is something wrong with him, get on your feet and show what his physical or mental challenge might be. Remember, this is *not* a comical situation. Feel for him.
**10.** Describe the woods where you hid.
**11.** Describe in detail what happened when you scared Benny. Remember, the situation got bad enough that you are now in trouble. What happened, *exactly?* You may tell these people something other than the truth in your monologue, but be honest right here.
**12.** Are there any more questions that you can ask yourself?
**13.** Write an autobiography for this character. Build your character a life.
**14.** Remember the magic "if." What would *you* do if you were in this situation?

Write out all of your answers. Be specific. It will get you closer to the truth of the scene, and you will create a stronger character.

# SAN FRANCISCO

We moved here from San Francisco. My father got transferred, and they sent us here. It's nice enough, I guess. Just real different. I haven't seen a single cable car since we got here. I haven't even heard the bells. And I don't think anybody likes the Giants here, either. Everybody loved the Giants in San Francisco. And the 49ers. Oh gosh! I saw this old guy, and everybody was shaking his hand, and I asked my dad who he was, and he said it was Joe Montana. I asked if he was a movie star, and my dad said he played for the 49ers. That's football. I said I thought he was too old, and Dad said he *used* to play for the 49ers. I said, "Good, because old people like him really shouldn't be playing any sports because they'll end up with a sore back." Golf. They can golf. All old people play golf. It's really easy, that's why.

**CHALLENGE:** To not speed through it. You must take your time because your audience has to see that you are picturing a memory. You used to live in San Francisco, but your audience did not. Your audience will want to see San Francisco with you. Take them on a journey.

**1.** What is this monologue about?
**2.** Who are you talking to?
**3.** Where are you?
**4.** What was your moment before?
**5.** What do you want? How are you going to get it? (see pages 16-17)
**6.** Tell us about San Francisco. Do research if you have to. You have to know San Francisco in order to make us know it.
**7.** Where do the Giants play baseball? Can you name any players on their team?
**8.** What was your house like in San Francisco? What is your house like now?
**9.** What are some other differences between San Francisco and where you live now?
**10.** Describe golf. Have you ever played? If you have, tell us about the golf course you played on. If no, tell us what you think it would be like.
**11.** Are there any more questions that you can ask yourself?
**12.** Write an autobiography for this character. Build your character a life.
**13.** Remember the magic "if": What would *you* do if you were in this situation?

Write out all of your answers. Be specific. It will get you closer to the truth of the scene, and you will create a stronger character.

# Prayers

(*Kneeling*) Dear God … Is that what you want to be called? Is God your whole name, or is that just your first name? My parents told me not to call old people by their first name. Like Mr. Archer—I know his first name is Archie, because I always hear people call him that. Why would his mom name him Archie when his name is already Archer? Does that seem funny to you? Anyway, he is old, so I would never call him Archie.

I saw some pictures of you, and you look even older than Mr. Archer, so I want to be sure that I'm not calling you by your first name. How old *are* you? If you made the world, then that means you were here even before the dinosaurs, and I happen to know that the dinosaurs are extremely old. Well, they would be if they were still around. So that means you're the oldest of all the old people by far. But then, you aren't really a person, are you? Maybe sometime you could come to school and explain everything to everybody … Sleep well, God. (*Getting into bed*) Thanks for making everything—especially this bed.

{ **CHALLENGE:** To not *try* to be funny. It will be funny if you are really honest and sincere. Also, make sure that you are thinking of these things in the moment. You knelt down to say your prayers, not to ask God his real name and how old he is. Have fun! }

**1.** What is this monologue about?
**2.** What was your moment before?
**3.** Describe your bedroom with lots of details.
**4.** What do you want? How are you going to get it? (see pages 16-17)
**5.** Describe Archie Archer. Where do you know him from?
**6.** What did God look like in the picture you saw?
**7.** What do you like about your bed?
**8.** Do you say your prayers every night? What do you ask for?
**9.** What do you know about dinosaurs?
**10.** What do you have to do when you wake up in the morning?
**11.** Are there any more questions that you can ask yourself?
**12.** Write an autobiography for this character. Build your character a life.
**13.** Remember the magic "if": What would *you* do if you were in this situation?

Write out all of your answers. Be specific. It will get you closer to the truth of the scene, and you will create a stronger character.

# Grandma's Fl❀wer (dramatic)

I was five years old the first time I saw a flower like this. I'll never forget it. We were going to see my grandmother. She was sick in the hospital, and my mom was really upset, so my dad said he would take Friday off of work and we could all go and visit her. I really love my grandma, so I was really excited.

We had been driving for about an hour, and I was looking out the window, and I saw a flower just like this one. I yelled for my dad to stop! He pulled over, and I jumped out of the car and ran back to the flower and picked it. When we got to the hospital, I gave it to my grandma, and she cried. Now I think of my grandma every time I see one. So, thanks for the flower. And thanks for making me think of my grandma.

**CHALLENGE:** To make us clearly see that you are being reminded of something that happened before in your life. It is your job as an actor to make us believe that the flower you just got triggered this memory. Your moment before is very, very important. Whenever you are doing a scene of an old memory, it is important to see images and not words.

1. What is this monologue about?
2. Where are you?
3. Who are you talking to?
4. What was your moment before?
5. What do you want? How are you going to get it? (see pages 16-17)
6. Describe the flower. Draw it if you can.
7. Describe where the flower was when you picked it. Remember, you saw it from the road.
8. Describe your grandmother in the hospital. Describe a time when she was not sick. What did you do with her?
9. Describe the car ride to the hospital. What was it like in the car? Was your mother crying? Was your father comforting her? Was it silent?
10. How did your parents act when you jumped out of the car to pick the flower?
11. Are there any more questions that you can ask yourself?
12. Write an autobiography for this character. Build your character a life.
13. Remember the magic "if": What would *you* do if you were in this situation?

Write out all of your answers. Be specific. It will get you closer to the truth of the scene, and you will create a stronger character.

# One-Minute Monologues for **GIRLS**

1MMs

# CALLING MOM

Yes, hello. May I speak to Maggie? … Maggie Richards? … I'm sorry? … No, I'm her daughter! … Yes I am! My name is Tiffany Richards. Who is this? … Well, Mrs. Van Winkle, I would really appreciate it if I could just speak to my mother … Of course she's there, she works there! … You want me to describe my mother? … Mrs. Van Winkle, are you new or something? … Okay, okay. My mother has blond hair and brown eyes. She's short, and she has a blue jacket … Yes, she's sort of pretty … Okay, she's really pretty … and sweet, yes … Mom! Why do you do that every time I call?

**CHallenge:** To not lose focus. You are on the telephone. Wherever you see an ellipsis (…), you have to fill that in with dialogue coming through the phone. For example, you said, *"Who is this? … Well, Mrs. Van Winkle, I would really appreciate it if I could just speak to my mother."* Obviously, during the ellipsis the other person responded, "This is Mrs. Van Winkle." Understand? It is your job as the actor to actually say the response to yourself. This ensures you are taking the proper pause. Use your imagination, and have fun!

**1.** What is this scene about?

**2.** What was your moment before?

**3.** Where are you?

**4.** What do you want? How are you going to get it? (see pages 16-17)

**5.** Why are you calling your mother? Have a good reason for calling her at work.

**6.** Describe where your mother works. Use details.

**7.** What is your mother saying on the other end of the phone? Be very specific.

**8.** What does Mrs. Van Winkle look like? Remember, you don't know she is your mother yet. When we hear someone's voice, we automatically draw that person in our mind.

**9.** Why does your mother fool you every time?

**10.** Tell us about the last time your mother fooled you. Who did she pretend she was that time?

**11.** How does Mrs. Van Winkle talk? If your mother fools you each time, she must change her voice.

**12.** Are there any more questions that you can ask yourself?

**13.** Write an autobiography for this character. Build your character a life.

**14.** Remember the magic "if": What would *you* do if you were in this situation?

Write out all of your answers. Be specific. It will get you closer to the truth of the scene, and you will create a stronger character.

# Mrs. Davenport

I saw Mrs. Davenport yesterday. She told me I look just like you. She tells me that every single time I see her. She says, "Sassy, your mother was the most beautiful girl in town. And you, darlin', you look exactly like her." She says that EVERY SINGLE TIME! At first I was flattered. That would mean that I am, or I'm going to be, the most beautiful girl in town, right? I know it's a small town, but still. Then, I was coming down the hall today, and I could hear Mrs. Davenport's voice, and I could see she was talking to Crystal Simms. She said, "Chrissy, your mother was the most beautiful girl in town." I am not kidding. Then, "And you, darlin', you look exactly like her." I couldn't believe it! Exactly, word-for-word, the same thing. So I started thinking that maybe Mrs. Davenport is a robot. Is that possible?

**CHALLENGE:** To not go too fast. Because you are excited—and maybe a little upset—you will want to hurry. Do not do it! Find a reason to not speed through it. For instance, you are talking to your mother. Maybe she is hard of hearing. Or maybe she is on the other side of the bathroom door getting ready to go out. It is also challenging to go from kind of a bragger to realizing that Mrs. Davenport says these flattering words to everybody. Have fun. This is one time where it is best to take yourself *too* seriously.

**1.** What is this monologue about?

**2.** Where are you?

**3.** You are talking to your mother. What is she doing? Describe her.

**4.** What was your moment before?

**5.** What do you want? How are you going to get it? (see pages 16-17)

**6.** Describe Mrs. Davenport. Be very specific.

**7.** Practice different voices for Mrs. Davenport. Why did you come up with the voice you came up with?

**8.** Who is Crystal Simms? Do you like her? Why?

**9.** Do you know Crystal's mom? Where do you know her from? Do Crystal and her mom look alike? Describe the similarities.

**10.** You've seen old pictures of your mom. Do you want to look like her? Why?

**11.** Describe the hallway you were in when you heard Crystal and Mrs. Davenport.

**12.** Are there any more questions that you can ask yourself?

**13.** Write an autobiography for this character. Build your character a life.

**14.** Remember the magic "if": What would *you* do if you were in this situation?

Write out all of your answers. Be specific. It will get you closer to the truth of the scene, and you will create a stronger character.

# Busy Bee

Okay. For the last time, my name is not Busy Bee! Do you really think my parents would name me Busy Bee? I mean, come on: "This is my daughter, Busy Bee. And this is my other daughter, Curious Cat, and this is our wonderful son, Dopey Doggy." It's not Busy Bee. It's B-Z-B. I already told you that.

My first name is Benziti. It's a combination of my grandfather's name, Ben, and his favorite meal, ziti. Then my middle name is Zootina. My mom's best friend was Tina, and I guess my parents decided to have me one day when they were at the zoo. Or something like that. And then my last name is Buchanan. Benziti Zootina Buchanan. My dad calls me Benzi, and my mom calls me Zooti. But my friends, my *true* friends, call me BZB. And I don't have to *explain* it to them every day.

**CHALLENGE:** To play it seriously. Although your real name may be ridiculous, you cannot play it that way. The humor will come out when you *don't* try to be funny. Also, even though you have had to explain this a bunch of times, don't be too frustrated. We tend to speak too fast when we get frustrated. Give some thought to who you are talking to. If it is a girl, you might be a little more patient. Or if it is a boy you like, you will speak differently to him than you would to a boy you don't like. Try saying it to different people until you think it is best. Have fun!

**1.** What is this monologue about?
**2.** Who are you talking to?
**3.** What was your moment before?
**4.** Where are you?
**5.** What do you want? How are you going to get it? (see pages 16-17)
**6.** What are your brother's and sister's names? Are they as strange as yours?
**7.** Describe your parents in detail.
**8.** What does your signature look like? Practice it.
**9.** Do you secretly like having a name that you have to explain? Why?
**10.** Describe your grandfather. What is ziti? Do you like it too?
**11.** Who *are* your true friends?
**12.** Are there any more questions that you can ask yourself?
**13.** Write an autobiography for this character. Build your character a life.
**14.** Remember the magic "if": What would *you* do if you were in this situation?

Write out all of your answers. Be specific. It will get you closer to the truth of the scene, and you will create a stronger character.

# Ask Chuck

I *want* to ask him to go to the dance, but here's the thing: First of all, I think he might be going on vacation. Supposedly he has relatives that live in Pennsylvania and he is going to visit them. At least, that's what Erin told me. That's another thing—Erin really likes him too. I think she might be lying to me about him going away so that she can work up the guts to ask him to the dance herself. But I know he doesn't like Erin. He likes her, but he doesn't *like* her. And I'm afraid he doesn't like Erin because he likes Tanya. And that's another thing. If I ask him and he says no because he likes Tanya, Erin will be mad at me for asking him, and I'll feel stupid because he likes Tanya. I am so confused. Maybe I should just ask Chuck.

**CHALLENGE:** You have three facts that you are talking about. You have to make sure your audience follows you all the way through the scene. Sometimes when we know what we are saying, we expect others to just follow along and we leave them behind. Don't go too fast, don't whine, and talk clearly. Take your time, and think as you go. When you say, *"That's another thing ..."* you must let it lead you to the second thing. Don't hurry. Don't act like you have a list of things to say. You want your audience to feel bad for you in the situation, but when you have to "settle" for Chuck, the audience will feel for him more. It is your job to make us feel sorry for Chuck.

**1.** What is this scene about?
**2.** Where are you?
**3.** Who are you talking to?
**4.** What was your moment before?
**5.** What do you want? How are you going to get it? (see pages 16-17)
**6.** Who is the boy you want to ask to the dance? Describe him in detail. Don't be shy.
**7.** Who is Erin? What is your relationship with her? Remember, you are afraid she will be mad at you.
**8.** Describe Tanya. How does it feel to think this boy might like her over you?
**9.** Who is Chuck? Why are you sure he would go with you? What is your relationship with him? Be specific.
**10.** Describe what you think the dance will be like.
**11.** Are there any more questions that you can ask yourself?
**12.** Write an autobiography for this character. Build your character a life.
**13.** Remember the magic "if": What would *you* do if you were in this situation?

Write out all of your answers. Be specific. It will get you closer to the truth of the scene, and you will create a stronger character.

# Gee Thanks, Dad

First of all, I want to say thanks for the new dresser and the loft that you built for me. It's really awesome, Dad. And the paint. I can't believe you painted my room. I've only been gone three days, and everything is ... changed. It's like I left and came home to a brand new life. And the little stickers that you put all over the walls—they are so cute. Especially those little puppy stickers with the big eyes. They're so ... um ... I just want to ask one little favor though. Just a tiny ... Do you think you could, maybe, ask me next time? I mean, I know you were only thinking of me and everything, and it's really nice. Really, really nice. But I kind of want to have a say next time. I mean, I mean it—I really, really, *really* want to have a say next time. I'm still your little girl, and I will always be your little girl. But this is important to me. Okay? (*Turn to leave.*) Okay. (*Turn back.*) Oh, and . . . no more stuffed animals. (*Smile.*) Please.

{ **CHALLENGE:** To make your audience understand where you are coming from without making them think you are an ungrateful brat. You have every right to ask this of your father, but you have to be careful not to hurt his feelings. Being assertive *and* sensitive is uncomfortable sometimes. Let your audience see your discomfort. }

**1.** What is this monologue about?
**2.** Where are you?
**3.** What was your moment before?
**4.** What do you want? How are you going to get it? (see pages 16-17)
**5.** Describe your father. What is he wearing? Is he doing something, or do you have his undivided attention?
**6.** What color did he paint your room? What color was it before? Describe how you really feel about the new color.
**7.** Where were you for three days? Be specific. Who were you with? What did you do?
**8.** Tell us about another time your dad did something for you without giving you any say. Make it up.
**9.** How is he responding to what you're saying?
**10.** What are you going to do now that you have spoken to your dad?
**11.** Are there any more questions that you can ask yourself?
**12.** Write an autobiography for this character. Build your character a life.
**13.** Remember the magic "if": What would *you* do if you were in this situation?

Write out all of your answers. Be specific. It will get you closer to the truth of the scene, and you will create a stronger character.

# PACKED

I think I might be all packed. I've got three pairs of socks, even though I hope I never have to put on *any* socks. I've got two pairs of shorts. There's four shirts. I'm bringing my Twinkling Tina shirt because it is so cool. I know I just wore it yesterday. You don't have to remind me. I have one pair of long pants in case we go someplace cold, which I hope we don't. Then I have my brown shoes and my sneakers. I'm going to wear my flip-flops on the plane. I love love love my flip-flops. I'll wear my flowery skirt and my blue tee shirt. And my hat! I can't forget my hat. I would make them turn the plane around if I forgot my hat! (*Pause.*) And I think that's it. My mom will bring everything I forgot. She always does ... Wait. How can she possibly know what I'm going to forget?

**CHALLENGE:** To not make the whole monologue sound like a big list. You have to keep changing your voice because each piece of clothing needs to tell a different story. Long pants mean cool or nice (a nice restaurant, an aquarium, a cave); flip-flops mean warm and sunny (the beach, the sand, poolside). You need to see things so the audience can see things with you. You're going on vacation. Have fun!

**1.** What is this monologue about?

**2.** Who are you talking to?

**3.** What was your moment before?

**4.** Where are you?

**5.** What do you want? How are you going to get it? (see pages 16-17)

**6.** Where are you going? Describe it clearly.

**7.** What would be your perfect vacation?

**8.** Have you ever been on an airplane? Describe it.

**9.** Draw your Twinkling Tina Shirt. Why is it your favorite?

**10.** Describe all of your clothes that you talk about here.

**11.** Where have you gone before where your mom had to remember the stuff you forgot? You can make it up.

**12.** Are there any more questions that you can ask yourself?

**13.** Write an autobiography for this character. Build your character a life.

**14.** Remember the magic "if": What would *you* do if you were in this situation?

Write out all of your answers. Be specific. It will get you closer to the truth of the scene, and you will create a stronger character.

# English Language

It doesn't make sense to me. I understand it's the English language. You say that every time. But why does it have to be so complicated? It's crazy. For instance, we say "to," like, "I have *to* feed the chickens." I don't have chickens. It's just an example. That's T-O, "to." Then there's the number two: T-W-O. W? Seriously? Then there's T-O-O "too." Like, "I have *to* go feed the chickens, *too*." That's a T-O and a T-O-O.

Who made up this language? Was it that guy William Shakespeare? It's just so confusing. Okay, like, second period. We call it "two," right? I might actually have to say, "I have *to* go *to* two, *too*." That doesn't even sound like English. That's why I love gym. (*Realizing what you said*) Gym *class*, not a boy named Jim. Just forget it.

**CHALLENGE:** To annunciate! You must speak carefully. Speak slowly and clearly so it makes sense. It will sound like nonsense, but it needs to make sense to your audience. You need to get worked up and a bit frustrated, but you cannot lose your words. You also have to make these discoveries about the differences in the word "to" in the moment. This is something you may have thought before, but you have not said it. Make it sound like this is the first time you've said it.

**1.** What is this monologue about?
**2.** Who are you talking to?
**3.** What was your moment before? What led up to this speech?
**4.** Where are you? Be very specific. What do you hear? Smell? See? Feel?
**5.** What do you want? How are you going to get it? (see pages 16-17)
**6.** List some other examples of confusing words from the English language.
**7.** What do you love about gym class?
**8.** What do you know about William Shakespeare? Why did you say that?
**9.** Describe your English teacher.
**10.** How is the person you are talking to reacting to you?
**11.** Are there any more questions that you can ask yourself?
**12.** Write an autobiography for this character. Build your character a life.
**13.** Remember the magic "if": What would *you* do if you were in this situation?

Write out all of your answers. Be specific. It will get you closer to the truth of the scene, and you will create a stronger character.

# One-Minute Monologues for **Boys**

# 1MMs

# THE WORST KIND OF FRIEND

Look, I know you think it was me that ate your lunch. And, I know that you also think I sold your Laser Blazer to Buddy. For the hundred-millionth time, I didn't. For all I know, you think it was me that told Brenda Clark that you wanted to take her to the dance, too. Right? Right. That's what I thought. You're something else. It wouldn't surprise me one bit if you thought that I forgot to invite you to my birthday party on purpose. Don't even say it. My feelings would be totally hurt if I heard you say it. I mean, what kind of friend would I be if I went and had the best party ever, with pizza and soda and—and a huge Laser Blazer marathon and everything, and I didn't tell you about it? I mean, what … I wouldn't want to be around someone who did that. I would hate that person, I think. You don't hate me, I hope?

**CHALLENGE:** To convince your audience that you *really* don't realize that you are a total jerk. When your character is rude and inconsiderate, you have to make us believe that you are the last to know. Even when your intention is to hurt someone's feelings, we have to believe that *you* don't mean it.

Try this: Read the monologue once like you are totally guilty of everything you are accused of. Then try it as if you are truly innocent. How is it different?

**1.** Who are you talking to?
**2.** What was your moment before? Be creative and thorough.
**3.** Where are you?
**4.** What do you want? How are you going to get it? (see pages 16-17)
**5.** Did you eat this person's lunch? What was it? Details!
**6.** Who is Buddy?
**7.** Who is Brenda Clark?
**8.** What is a Laser Blazer? Be creative. This is your opportunity to invent a toy.
**9.** Who was invited to your party? Be specific.
**10.** What is it about this person that you don't like?
**11.** What is it that you, the actor, have in common with this character? What are some differences?
**12.** Are there any more questions that you can ask yourself?
**13.** Write an autobiography for this character. Build your character a life.
**14.** Remember the magic "if": What would *you* do if you were in this situation?

Write out all of your answers. Be specific. It will get you closer to the truth of the scene, and you will create a stronger character.

# SEAMUS (Shay-mus)

Why? Why did my parents have to name me Seamus? I get it that it was a family name. My granddad was Seamus, and my dad's great uncle's father's … dad was Seamus. Or something. But it is so, like … I'm called Amos. I hate that name! I'm called Shameless. Blameless, I got called yesterday. And then the spelling! S-E-A-M-U-S? That doesn't even spell Seamus! Doreen called me Sea Mouse. There's Sea Monster, Seymour … I've heard Sea Mist, Seamless. But yesterday took the prize. I come in, and on my desk was this shirt. I was all, "Oh, cool. A shirt!" Then I see on the back it said, "Shame On You Sea Moose!" (*Laughing*) I mean, I kind of like it, but come on!

**CHALLENGE:** To not whine. Nobody likes to hear someone whine. Sometimes complaining can sound like whining. To stop sounding whiney, you have to really believe what you are complaining about. And don't talk too fast. It is also challenging to laugh. Have fun making fun of yourself.

Try this: Choose an older person to tell this to. Then try saying it to a little kid. How is it different? Which did you prefer?

**1.** What is this monologue about?
**2.** Who are you talking to?
**3.** What was your moment before?
**4.** Where are you?
**5.** What do you want? How are you going to get it? (see pages 16-17)
**6.** Where in Ireland is your family from? Choose a place. Look it up. They are very proud people. Do some research. Create a family.
**7.** What are your brothers' and sisters' names?
**8.** How does it really make you feel to be called different names? Nicknames can be very endearing. Is there a part of you that likes the attention?
**9.** Describe the different people who named you these names. Who is Doreen?
**10.** Do people make fun of you because you are fun? Shy? Easy to pick on? Why do they pick on you?
**11.** Who made the shirt and left it on your desk? Be specific about who this person was. Remember, it made you laugh.
**12.** Are there any more questions that you can ask yourself?
**13.** Write an autobiography for this character. Build your character a life.
**14.** Remember the magic "if": What would *you* do if you were in this situation?

Write out all of your answers. Be specific. It will get you closer to the truth of the scene, and you will create a stronger character.

# Cross Country

I just think they cheated. I know, I know. Whenever I lose, I accuse the other guys of cheating. I get it. But this time I am sure of it. I was like fourth, maybe fifth, the whole race. There was one kid with yellow shoes. I knew I was never going to catch him. He was ridiculous. I think he must have been, like … in college or something. Then there was this guy … two guys, with red shorts. They were too fast. I was cool with not catching them. Then, there was this kid Jake … He actually introduced himself to me at the starting line: "I'm Jake Jerome. Good luck today." I was like, are you serious? To myself I said that. Then, when we were all done, I see that I came in eighth! I was … I mean … I never even saw these guys. I'm just saying, I don't remember them passing me. I just think they all cut through the creek.

{ **CHALLENGE:** To take your time and really make us think you just got done running a race. You will want to talk very fast because you are defending yourself. Talk quickly, but carefully. We want to see all these boys you are talking about. Have fun! }

**1.** What is this monologue about?
**2.** Who are you talking to? Try different people (parents, a brother, a sister, a friend). Does it change the way you say it? It should. Decide who you want to talk to.
**3.** Where are you?
**4.** What was your moment before? What happened just before you began speaking?
**5.** What do you want? How are you going to get it? (see pages 16-17)
**6.** Describe Jake Jerome. Did he shake your hand?
**7.** Draw the whole course that you had to run.
**8.** Do you really believe these guys cheated?
**9.** Tell us about the whole race from start to finish. Describe the guys in the red shorts and the guy in the yellow sneakers.
**10.** Are you still tired? Did you use that when you said your monologue? If not, where did you rest? How long ago was the race? Describe it clearly.
**11.** Are there any more questions that you can ask yourself?
**12.** Write an autobiography for this character. Build your character a life.
**13.** Remember the magic "if": What would *you* do if you were in this situation?

Write out all of your answers. Be specific. It will get you closer to the truth of the scene, and you will create a stronger character.

# Longer Monologues for Boys or Girls

L...

LMs

# Summer Vacation

I have to write about my summer vacation. I hate it. I don't feel like we did anything fun. We went to see our cousins in California. They live in Santa Monica. There's a beach and a pier. It's pretty cool, I guess. Oh, I saw the pier on a TV show last night. My brother and I were like, "Hey! We were there!" That was neat. Oh, this guy on the pier caught a stingray. It was like (*show it*) this big. He let us see it, then he threw it back. It was awesome. Then we rented bikes and rode along the beach all the way to Venice. Venice, California.

Venice is amazing. It is so weird! People are like … We watched this guy walk across this huge pile of glass. He just seriously walked across broken glass with his bare feet. Then this other guy was riding his skateboard with his dog! I'm serious—not like he was holding onto his dog while he rode his skateboard. He was on one skateboard and his dog was on another skateboard. They went right past us. We were laughing so hard. And then there was this woman with a beard. Really—like a long … beard. And no teeth! She was so friendly and bizarre. And funny! (*Pause.*) I don't know. I guess I could write about that.

{ **CHALLENGE:** This monologue must start off dull and uninteresting. That is your job. Then as you relive the trip, you realize how much you loved it, and your excitement must build as you go along. But don't get too excited either, because the truth is that you really don't want to do the assignment at all. }

**1.** What is this monologue about?
**2.** Who are you talking to?
**3.** What was your moment before?
**4.** Where are you?
**5.** What do you want? How are you going to get it? (see pages 16-17)
**6.** Describe your cousins, their house, and the room you stayed in.
**7.** Look up Santa Monica, the Pier, and Venice Beach so that you can visualize being there.
**8.** What was that stingray like?
**9.** Describe the bike that you rented.
**10.** Draw the woman with the beard. Why do you think she didn't have any teeth?
**11.** What else did you see on the pier? Create your pier and use your imagination.
**12.** Are there any more questions that you can ask yourself?
**13.** Write an autobiography for this character. Build your character a life.
**14.** Remember the magic "if": What would *you* do if you were in this situation?

Write out all of your answers. Be specific. It will get you closer to the truth of the scene, and you will create a stronger character.

# Chores

I tried! I swear I did. It was totally Beanbag's fault. I know you told me that it can never be the dog's fault, but this time I think you'll agree. And because Beanbag is more Danny's dog … He's always saying that, right? I just think he should have to help me. Okay, listen. I was pulling the trash down to the curb like you said. Well actually, Beanbag was pulling it. It's really funny. I tie his leash to the bin … (*See Mom's dirty look*) … Anyway, we were going down the driveway, and this rat—I swear, Mom, it was like (*show with your hands*) this big! It leaps out of the garbage bin and almost lands on Beanbag's back! I screamed, and Beanbag went ballistic! He started chasing this rat, and the stupid thing ran back into the garage.

Well, Beanbag is still tied to the bin, right, so garbage is going everywhere. Then Sandra comes out. She's like, "What the …?" Beanbag is freaking out! I'm freaking out! Garbage is everywhere, and this rat runs, like, right at her. I never knew Sandra was that athletic. If Mrs. Jackson had seen her, Sandra definitely would not have gotten cut from cheerleading. Anyway, so she leaps up, and she's hanging from the shelf where all the paint is, and she's screaming at the top of her lungs. Well, of course the shelf broke. She's like a hundred pounds and she's hanging from it. And that's how that paint got all over the place. It was unbelievable! And Beanbag ran the bin right into Dad's truck. That's where that scratch came from. It was crazy, Mom. Totally scary. Sandra's still, like, crying upstairs. I put Beanbag in her crate. I can't go back into the garage, Mom. Ever. So, I was just waiting for Danny to get home so he could … Are we gonna eat soon?

**CHALLENGE:** To speak fast and be very animated and excited. You must remain in control so the audience hears every word. This monologue shifts from past to present. When you do this, your speed must change as well. You must have clear images so the audience can completely see this taking place. Volume, controlled speed, and clear images will win your audience. Have a blast!

**1.** What is this monologue about?
**2.** Where are you?
**3.** What are you doing when your mother walks in?
**4.** Where is the garage right now? Be specific and clear as you refer to the garage. Point to it.
**5.** What do you want? How are you going to get it? (see pages 16-17)
**6.** Describe the mess in the garage. Be very specific with the destruction.
**7.** Describe Beanbag and your sister. Use details. Make them real.
**8.** Describe the scratch on your father's truck. What will he say about it?
**9.** Are you telling the truth? Are you exaggerating? Do you always get in trouble?
**10.** Do you expect your mother to believe you? Why?

CONTINUES ▶

**11.** Describe the rat in perfect detail. Draw it if you can.

**12.** How do you feel about Beanbag being Danny's dog? Why did you say that?

**13.** Are there any more questions that you can ask yourself?

**14.** Write an autobiography for this character. Build your character a life.

**15.** Remember the magic "if": What would *you* do if you were in this situation?

Write out all of your answers. Be specific. It will get you closer to the truth of the scene, and you will create a stronger character.

# Family Reunion

I went to my family reunion on Sunday. Can I tell you, I have the strangest family ever. My cousin Patricia is the only normal person. Well, my mom and my dad too. But there are people that I'm related to that I would never even go near if I didn't have to. My cousin Vince—they call him Vincer. What is that? Isn't that a reindeer's name? Anyway, we're outside at this park, and we're under, like, this roof thing, and Vince—*Vincer*—decides to climb on top of it. So he shimmies up one pole and scoots on top. Then he stands up and yells, "Hey Mom, look up here! I'm a dancing fool!" And he starts doing this dance, like (*do a funny dance*). His mom, my Aunt Trinity, almost has a heart attack. She is screaming at the top of her lungs, "Vincer, you imbecile! Get down from there! Daddy's in prison, and we don't have any insurance!" See, this is weird because she just got done telling everybody that my Uncle Carl was on the road with his band. So, Vincer is dancing and Aunt Trinity is screaming. All of a sudden, Vincer comes straight through the roof, and he lands right on the cake my Aunt Cora Lee made. The cake went all over everybody, like … POW! Patricia, me—covered. It went everywhere! Then Vincer slowly looks around at everybody and smiles. Then my Aunt Trinity called him a horse's neck, or something like that, and she chased him all around the park just screaming. It was so funny. We were all laughing. I think she was just scared. And probably embarrassed about Uncle Carl. They never even came back. Not even for their bowl that they brought chips in.

{ **CHALLENGE:** To take your audience through this big picture carefully. You will be tempted to speed through, but don't or you will lose your audience. You also have to come up with a funny dance and a voice for your aunt. Don't overdo it. Make the story engaging, like when it happened. The funniness is in the words. Tell a story. }

**1.** What is this monologue about?
**2.** Who are you talking to?
**3.** What was your moment before?
**4.** Where are you?
**5.** What do you want? How are you going to get it? (see pages 16-17)
**6.** Draw the pavilion. You must have a clear picture of it so your audience can get a clear picture too. Think of the pole Vincer shimmied up, the roof, the tables, and so on.
**7.** Describe Vincer. What is he wearing? How old is he? What's his hair like? Are there any more children in his family?
**8.** Describe your Aunt Trinity. How is she related to you?
**9.** What did people say about them after they left? Be specific. Create a funny conversation.

CONTINUES ▶

**10.** Describe the cake that Aunt Cora Lee made. How did she react when Vincer landed in it?

**11.** Where did Aunt Trinity chase Vincer to? Could she catch him?

**12.** Are there any more questions that you can ask yourself?

**13.** Write an autobiography for this character. Build your character a life.

**14.** Remember the magic "if": What would *you* do if you were in this situation?

Write out all of your answers. Be specific. It will get you closer to the truth of the scene, and you will create a stronger character.

# SLAMP

I had the strangest dream last night. It was so real, and so … bizarre. I sat up really slowly, and I just kind of looked at myself, like, are you … I mean, are *we* okay? Then I just sat there like … (*Start describing the dream.*) Okay, so, I was at a doctor's appointment. But it wasn't my doctor. In fact, I don't even know where we were. But I was in this room that just smelled horrible. Then this doctor comes in with these papers, and he doesn't even look at me, and he says, "You've got Slamp." I said, "What the heck is Slamp?" He said, "Your brain is turning to pudding." He says that, then just turns and walks out. Then my Mom walks in, and she's crying really hard. And I went to say, "I'm all right, Mom." But I sounded like this: (*In Slamp voice*) "I'm all right Mom." And she starts crying hysterically, "My daughter is a zombie!" And I said, (*Slamp voice*) "No I'm not. I just have Slamp!" Then she starts to leave, like she's just going to leave me there sitting on this table. And I jumped up to go to her, and I was like, "(*Slamp voice*) Mom, please, don't go. I'm all better. Look!" And I tried to walk over to her, and this is how I was walking. (*Do the Slamp walk.*) And I'm trying the door, but it's locked. Then my mom comes back in with the doctor and the doctor says, "She is not a zombie. I do not treat zombies here! Her brain has only turned to pudding. There is a big difference." Then my mom looks at me, and I go to smile at her, but I smile like this (*Slamp smile*). Then she just cries and runs out again. Then I woke up. I just sat there in my bed, like, what the heck was that? Thank God it was only a dream … I look fine now, right, you guys?

**CHALLENGE:** This monologue requires that you use four different voices: You, you with Slamp, the doctor, and your mother. You must not rush or it will blur together. It is a test of your patience. The humor is in your timing. Have very clear images in your head, and your audience will see them as well. Remember the dream as you go. Have a blast!

**1.** What is this monologue about?
**2.** Who are you talking to? Be very specific.
**3.** What was your moment before?
**4.** Where are you?
**5.** What do you want? How are you going to get it? (see pages 16-17)
**6.** Describe the doctor. Be specific.
**7.** Describe the doctor's office. What did it smell like?
**8.** Describe exactly how your mother was looking at you.
**9.** How are your friends reacting to this story?
**10.** Describe how you felt when you woke up. Did you go back to sleep? Are you exhausted? Try it different ways—excited, exhausted, scared, confused. What works best?

CONTINUES ▶

**11.** Find a mirror to help you find your Slamp monster. Work it out. Really exaggerate.

**12.** Are there any more questions that you can ask yourself?

**13.** Write an autobiography for this character. Build your character a life.

**14.** Remember the magic "if": What would *you* do if you were in this situation?

Write out all of your answers. Be specific. It will get you closer to the truth of the scene, and you will create a stronger character.

# *Yankee Baseball*

My father told me that if the Yankees win the World Series again, he is going to throw the TV out the window. He says that it isn't fair because they have more money, so they buy better players. He can't stop talking about it. Every night he just rants on. He was yelling, "Who cares if A-Rod is dating so and so? Let them have steroid babies on the Moon, for all I care!" I'm just trying to do my homework, but I hear him out there. And then Mariano Rivera broke the pitching record and I thought he was going to jump off the roof. He screamed on and on about cheating and about getting players from other countries and blah blah blah. It's embarrassing. I keep shutting the windows in our house so the neighbors won't call the police.

But the other night he said something about Derek Jeter. I think he called him washed up or something. My mother went charging into the room and said—and this is exactly what she said—she said, "If you say one more word about Derek Jeter, I am going to pack your bags, load them into that little truck of yours, and aim you toward your parents' house in Boston." My dad didn't say anything after that. (*Pause.*) Steroid babies on the Moon? What is that?

**CHALLENGE:** You have to use different voices. You have your father and you have your mother. That can be tricky. Do not speed through this. You have to decide how you feel about baseball. Your attitude will greatly affect this monologue. For instance, if you hate baseball, then all of your father's ranting will seem even more ridiculous. But if you secretly love the Yankees or the Red Sox or another team, it might seem more like you are making fun of your father. You decide which you like more. And you must do some research for this monologue so you can know who you are talking about.

**1.** What is this monologue about?
**2.** Who are you talking to?
**3.** Where are you? Be specific.
**4.** What was your moment before?
**5.** What do you want? How are you going to get it? (see pages 16-17)
**6.** Describe the room where your father watches baseball.
**7.** Who is A-Rod? Mariano Rivera? Derek Jeter?
**8.** Describe your neighborhood. How close are your neighbors' houses? Could they hear your dad yelling?
**9.** Describe the room where you were doing your homework. What was your homework?
**10.** What did your father mean when he said "steroid babies on the Moon"? Draw one.
**11.** Are there any more questions that you can ask yourself?
**12.** Write an autobiography for this character. Build your character a life.
**13.** Remember the magic "if": What would *you* do if you were in this situation?

Write out all of your answers. Be specific. It will get you closer to the truth of the scene, and you will create a stronger character.

# Crybaby (dramatic)

I don't cry anymore. I stopped. I don't even remember the last time I cried. Probably not since before middle school. Todd used to call me a crybaby. You know Todd—my brother? (*Pause.*) When I really think about it, I wonder if I could cry even if I wanted to. I used to cry over everything. It was just what I did. I drove my family nuts! When I was mad, I would just cry. If I was frustrated, if I was scared … I cried when I was hurt. Everybody did that, though—cry when you were hurt. I cried when I was sad. I remember I cried when I saw *Bambi* … That was so sad. (*Pause.*) Crying made me feel better. Is that weird? Even when Todd called me a crybaby, it just felt … I just (*long pause*) I can't remember his face. Honestly. I can only remember his face when I feel like, like I could cry. (*Pause.*) But then he's going to call me a crybaby, and it goes away. They both just … His face and my urge to cry both just go away. Every time.

**CHALLENGE:** Pacing. This is an emotional piece. You don't reveal very much, but your audience needs to feel that you are in pain based on what you *aren't* saying. We will know something happened to your brother, but you don't say it. You will take us along with you if you use your punctuation and your pauses. This monologue might make you sad when you do it, but you cannot cry—at least not when you perform it. Be strong, and have fun!

**1.** What is this monologue about?
**2.** Who are you talking to? A friend? A doctor? A teacher? God?
**3.** What was your moment before? What happened just before you began to speak?
**4.** Where are you?
**5.** What do you want? How are you going to get it? (see pages 16-17)
**6.** What happened to your brother Todd? Be very specific. Build a story around it.
**7.** What kinds of things make you cry? How do you feel when you cry? Try to imagine it if you could not cry.
**8.** Tell us about *Bambi*. If you never saw it, either watch it or read up on it.
**9.** How did it make you feel to be called a crybaby?
**10.** Where did you go before middle school? Describe your elementary school. Was it at this time that something happened to your brother?
**11.** Are there any more questions that you can ask yourself?
**12.** Write an autobiography for this character. Build your character a life.
**13.** Remember the magic "if": What would *you* do if you were in this situation?

Write out all of your answers. Be specific. It will get you closer to the truth of the scene, and you will create a stronger character.

# LOST, I THINK

Here's what's gonna happen if we go left ... That's west, I think. If we go left, we'll come to Maynard's Creek. I think. Can anyone hear it? (*Listen.*) It probably doesn't have any water in it, anyway. So if Maynard's Creek is over there, then that means straight ahead of us should be Gilly's Cove. You ever been there? They call it that because Gilly McDonnell—that's Billy McDonnell's grandfather—saved two boys from drowning down there. I think that's what it was. Or he saved them from a bear. Anyway, cool place. That should be straight ahead, I think. That means if we go right, we should cross over Eden's Meadow, go over Carpenter's Ridge, and end up back at the cabin. Trouble is, there's over fifty cabins out here. Like, fifty-one, I think.

My father told me never to stay in cabin fifty-one because Old Lady Hutchins' ghost is in there. I asked why she was there, and he said he reckoned she only wanted them to build fifty cabins. I thought that was a stupid reason to haunt a place ... Those are our choices. I can't think of anything else ... Oh. (*Pull out your cell phone.*) We could call my dad and ask him, if we want.

**CHaLLenge:** To speak clearly and really act like you know what you are talking about. This monologue jumps around a lot. Even though you say, "I think" a lot, you have to seem in control. You have to be convincing. You are probably not telling the absolute truth, but you have to sound like you are. Take your time. Have a clear picture in your mind of where everything is. Point to different parts of the room to represent different places. Be specific and have fun!

**1.** What was your moment before? What exactly led up to this scene?
**2.** Who are you talking too? Be very specific.
**3.** Describe where you are in this scene. You know what's left and right and straight, but where are you? Can you draw it? It will make a difference if you are in the woods compared to in a field or on a mountain. Have you ever been there before?
**4.** What do you want? How are you going to get it? (see pages 16-17)
**5.** Are you lost? Describe how sure or not sure of yourself you are.
**6.** Draw Gilly's Cove. And who is Billy McDonnell?
**7.** Describe your father. Why would he know right where you are?
**8.** What's in the cabin that you are looking for?
**9.** Describe the ghost of Old Lady Hutchins. Can you draw it? Does she make noise? Wail?
**10.** Did you know you had your cell phone all along? Or did you *really* just remember it was there?
**11.** Are there any more questions that you can ask yourself?
**12.** Write an autobiography for this character. Build your character a life.
**13.** Remember the magic "if": What would *you* do if you were in this situation?

Write out all of your answers. Be specific. It will get you closer to the truth of the scene, and you will create a stronger character.

# Water Balloon

First of all, you can't possibly know how I feel. You weren't there. It was horrible! You can't even imagine it. Well ... you could probably imagine it. I'm not saying that. You do have a great imagination. But seriously, you weren't there. It was the worst thing that has ever happened to me by far. You should have seen this water balloon flying through the air. It was like a bomb! It was huge, and it was, like (*show the size with your arms*) ... but it was blobby. And it was fast, like someone launched it from a launcher. And it ... Don't laugh. It is so not funny. It hit me— please? It hit me right in the face! (*Pause.*) I swear, if you do not stop laughing right this second ... Are you done? I will never speak to you again! (*Pause.*) Thank you. It just came flying over the fence, and it was so scary. I don't even know who threw it. Some older kid, probably. It came from over by your house. Why are you still laughing? (*Short pause.*) Thank you. Someone must have been back behind your house in your yard. (*Pause.*) You didn't see ... Wait. Where were you? You should have been able to see them back there. (*Pause, staring at your friend.*) Wait a minute. You bought balloons last Saturday for your birthday party ... OH MY GOSH! (*As you chase your friend who has just took off*) If I ever get my hands on you!

**CHALLENGE:** You have to convince your audience that you are in distress. But, even though you are freaked out, your audience must hear your words clearly. And you have a huge realization when you discover it was your friend who threw the water balloon. Convincing your audience that you just realized that it was your friend can be tricky. Good luck, and have fun!

**1.** What is this monologue about?
**2.** Where are you?
**3.** You are talking to your friend. Describe this friend in detail.
**4.** What was your moment before?
**5.** What do you want? How are you going to get it? (see pages 16-17)
**6.** How long ago did this happen? Are you still wet? If you are, make us see that.
**7.** Draw a picture of where this all happened.
**8.** When you chase your friend off, where are you going? What's right offstage?
**9.** Describe the balloon. How big is it? How did it fly through the air?
**10.** Describe exactly what happened when the balloon hit you. Did you fall? Scream? Cry? The more you know about this incident, the clearer it will be for us.
**11.** Are there any more questions that you can ask yourself?
**12.** Write an autobiography for this character. Build your character a life.
**13.** Remember the magic "if": What would *you* do if you were in this situation?

Write out all of your answers. Be specific. It will get you closer to the truth of the scene, and you will create a stronger character.

# THE PHONE CALL (dramatic)

*(You are pacing. You are nervous, apprehensive. Without a fake phone in hand, you pretend to be on the phone.)*

Mrs. Carter? Hi, it's Sean. How are you? I'm trying to call you because … (*Try again.*) Hello, Mrs. Carter? Yes, hi again. It's … (*Try again.*) Mrs. Carter? Yes, hi. I'm Sean. I mean, it's Sean … (*Again.*) Good afternoon, Mrs. Carter. It's Sean. How are you today? It is really wonderful that I'm talking to you … It is wonderful to hear your … It is nice to talk to you. Listen, um … Is Terry there? I mean … Terry isn't there, right …? (*Try again. This is difficult, but you are gaining confidence.*) Mrs. Carter, it's Sean Moore. Remember you always said that you would want to know if any of us was ever doing … anything bad? Remember you said you would want us to tell you if anyone around us was ever doing drugs or anything? Remember you told us that? And remember you said to stay away from Eldridge Street, especially by the projects …? Mrs. Carter, Terry didn't come home after school today, right? (*Long pause. Pull a cell phone out of your pocket. Think about it, then dial and pause again.*) Hello … Mrs. Carter?

**CHALLENGE:** To show that you are nervous and apprehensive, but determined. Sometimes when we are sure we have to do something, we just figure it out. Let your audience watch you figure it out. Take them with you. Notice how the ellipsis (…) is being used here. You are on the phone—a fake phone call—but you are not talking to anyone. The ellipsis in this case is hesitation and confusion.

**1.** What is this monologue about?
**2.** Where are you?
**3.** What was your moment before?
**4.** Describe Mrs. Carter.
**5.** What do you want? How are you going to get it? (see pages 16-17)
**6.** How do you think Mrs. Carter will react to your phone call?
**7.** Describe Terry. Use a lot of detail. Why is Terry so special to you?
**8.** Describe Eldridge Street. Use a lot of detail.
**9.** Think about what this will do to your relationship with Terry. How do you think Terry will react?
**10.** Have you talked to anyone else about this? Why are you making this phone call?
**11.** Are there any calls you wish you had made in your real life?
**12.** Are there any more questions that you can ask yourself?
**13.** Write an autobiography for this character. Build your character a life.
**14.** Remember the magic "if": What would *you* do if you were in this situation?

Write out all of your answers. Be specific. It will get you closer to the truth of the scene, and you will create a stronger character.

# Pet Assignment

This assignment seems so simple, but it is taking me *forever!* How hard can it be to write a funny story about one of your pets? They are always doing funny things ... but I can't think of anything! I went and watched my hamster for, like, an hour to see if it would do something funny, but it just wanted to sleep. I said, "Come on, Bozo! You run in that squeaky wheel all night long, and now I'm counting on you, and you just sleep." I put him on the floor, and he just looked all around like (*imitate the hamster looking around*) ... I think he's afraid of Daphne.

Daphne is another one! This cat is the *funniest* animal ever! She's hilarious ... but I can't think of anything she actually does. She was staring out the window, so I snuck outside and crawled up to the window to look at her. She just stared at me (*be totally still and imitate the cat staring*), like she was stuffed or something. I'm like, "Come on! Do something!" I think they know I have an assignment and they're all pretending they're brain-dead.

Then Trouser! Trouser is the most disappointing of all. This dog is part Basset Hound, part Dachshund, part ... bat, I think. She's hysterical, usually. But today she wouldn't get off the couch. I threw her squiggly-piggly toy and I gave her a biscuit. I even asked her if she wanted to go to the P-A-R-K? I actually said "park," though. We only spell it when ... never mind.

Anyway, I know everyone else is going to have such funny stories. But my stupid pets are just ... I'm so bummed!

**CHALLENGE:** To make your audience laugh while you try to convince them that nothing is funny. You have to play it straight. Even when you imitate the animals, *don't* overdo anything. The humor will come with what you *don't* do. Use your pauses fully. And don't *play* frustrated. You *are* frustrated, but keep it under control. After all, couldn't you just make up a story about a funny pet? But you don't. That is already funny. Use your imagination, and have fun.

**1.** What is this monologue about?
**2.** Who are you talking to? Try it once saying it to a friend or someone your own age. Then try saying it to an adult. Decide which you like more.
**3.** What happened the moment before you started this monologue?
**4.** Where are you?
**5.** What do you want? How are you going to get it? (see pages 16-17)
**6.** Have a very clear picture of all the pets—their color, size, smell, and so on. How long have you had them? Where did you get them? Draw them. We must see your pets. We will see them only if you do.
**7.** Describe Trouser's squiggly-piggly toy.
**8.** Does Daphne usually go after Bozo? Describe it.
**9.** Practice imitating Bozo in the mirror. And Daphne.

**10.** Describe where you were when you went outside to look at the cat.

**11.** Are there any more questions that you can ask yourself?

**12.** Write an autobiography for this character. Build your character a life.

**13.** Remember the magic "if": What would *you* do if you were in this situation?

Write out all of your answers. Be specific. It will get you closer to the truth of the scene, and you will create a stronger character.

# POOL HOPPING

(*Whispering*) You have to be really, really quiet. You can't make a sound. I know *I'm* talking right now, but you can't talk. If we both try and talk at the same time, we'll need to get louder, and then we'll get caught. (*Look around.*) When you are trying to sneak into someone's swimming pool, you always have to remember if they have a dog or not. Dogs are a dead giveaway every time. Also, don't bring anything that you might drop. That would be bad. And don't ever go to the same pool two nights in a row. I know I was just here last night, but I was really careful. (*Stand up straight. YOU ARE CAUGHT!*) Oh hi, Mr. Mason. Sure is a nice night out, isn't it? My friend and me were just walking around. He thought maybe we lost our softball over here, and so we are just seeing if we can find it. I told him there's, like, no chance that it came all the way over here, but he said, "No, no, we should look over by the Masons' pool because I swear I heard a splash," and I said, "That's crazy. Nobody can hit a ball that far." And he said he once hit a ball so far that it disappeared from his naked eye. He said that. He said, "I couldn't see it with my naked eye." Him right here said that. That's what he said. So we came over here. I know it's late at night and we should have come earlier … He just … We just remembered about the splash, and … We'll just go. Thanks a lot. (*Exiting*) Have a nice night.

**CHALLENGE:** First, you have to use a stage whisper. That is a whisper that can still be heard in the back row of a theater. It is hard, so practice it. Then you have the challenge of getting caught. You have to totally change from sneaking to getting caught. Keep it realistic. You just got caught trespassing by an adult, and the consequences could be very serious. Remember that. Convince us you are scared without overacting. Have a blast!

**1.** What is this monologue about?
**2.** What was your moment before?
**3.** Who are you with?
**4.** Where are you? Be very specific. Have you already climbed the fence? Are you about to climb it? Are you beside the house?
**5.** What do you want? How are you going to get it? (see pages 16-17)
**6.** Describe what it was like the last time you pool hopped. Who were you with? How long did you stay in the water? Did you almost get caught?
**7.** Describe Mr. Mason. Does he have a flashlight? Is he a friend to your parents?
**8.** Describe where you were playing softball earlier. Or was that all a lie?
**9.** Describe the pool.
**10.** What did you do the last time you got in trouble? What was your punishment?
**11.** What are you wearing? Remember, if you are in a bathing suit, you are more vulnerable.

**12.** Are there any more questions that you can ask yourself?

**13.** Write an autobiography for this character. Build your character a life.

**14.** Remember the magic "if": What would *you* do if you were in this situation?

Write out all of your answers. Be specific. It will get you closer to the truth of the scene, and you will create a stonger chrace

# The Flying Dream

It was just a dream, but it was so real. It was incredible. I couldn't tell if I was awake or asleep. I mean, you'd think I would know it was a dream when Corndog came flying in my bedroom window, but I didn't. She landed on my bed, and I sat up and just stared at her. Then she said, "What are you waiting for? Get on." So I put my arms around her neck, and she just turned and flew back out the window. I was so scared. But not really. I mean, I was, but I wasn't. She just knew how to fly!

So she says, "I thought we'd take a ride over by your school." And I said, "But Corndog, how do you know where my school is? You've never been there." And Corndog says, "I know a lot of things." I'm talking to my dog! She says, "I know that's your friend Christa's house right down there." And she pointed at your house! You were on the roof! I just remembered! You were waving at me. Were you on the roof ... never mind.

Then she told me to hold on really tight, and she just started doing this roll like a corkscrew on a roller coaster. And I just started screaming, "CORNDOG! CORNDOG!" And then I woke up, and Corndog was just laying there on my bed staring at me. So I got close to her, and I told her to speak. I said, "Speak, Corndog. Say Christa." She just barked, like, "What?"

{ **CHALLENGE:** You need to make the audience see the same thing you saw and believe it the same way you did. You will also need to come up with a voice for your dog. When we have an amazing dream, we get very excited to share it, so be careful not to talk too fast. Visualize the flight. Have fun! }

**1.** What is this monologue about?
**2.** You are talking to Christa. Who is she?
**3.** What was your moment before?
**4.** Where are you?
**5.** What do you want? How are you going to get it? (see pages 16-17)
**6.** Describe Corndog in detail, especially size.
**7.** Tell us how you came up with the name Corndog. Be creative.
**8.** Describe what you see if you fly out your bedroom window. It does not have to be your own bedroom. Use your imagination.
**9.** Describe your bedroom.
**10.** What else did you see on your journey?
**11.** Are there any more questions that you can ask yourself?
**12.** Write an autobiography for this character. Build your character a life.
**13.** Remember the magic "if": What would *you* do if you were in this situation?

Write out all of your answers. Be specific. It will get you closer to the truth of the scene, and you will create a stronger character.

# The Dent|st

(*Sitting in the dentist's chair*) Just, listen to me for just one minute, Mr. Bens—Doctor Bensley. Sorry. It's just that you're Sheryl's father, so it's always so weird to call you "Doctor." Even though obviously you are one. At least I didn't call you Don, right? (*Nervous laughter*) So, Dr. Bensley, um, I need you to promise me you won't get mad, okay? All right, I'm just going to say it. I have tried! Honest, I have. But I hate brushing my teeth! I don't know why. It's like, I'm always too tired by the time I go to bed, and I'm always hurrying to get ready for school, and … I know I have to do it, but I can't stand it! And I know it only takes a second, and I know it will save my teeth and all that stuff. But still, I hate doing it. And I hate thinking about it all the time. I would just like to one night go to bed and not brush my teeth and not think about it and feel guilty about it. It's like every single night I think of my teeth, and then I think of not brushing them, and then I think of your face, and then I think of Sheryl and how beautiful her teeth are, and then I have to get up and brush my teeth! It drives me crazy! Just please tell me that once in a while it is fine to skip it. Please? I'm begging you.

**CHALLENGE:** To not hurry through it. You are familiar with your situation. You know your dentist, his daughter, and the chair. You talk about what you go through every night. Sometimes, when we are very familiar with what we are talking about, we rush too fast. Do not rush! You also have to make your audience think you are talking to the dentist from the dentist's chair without talking straight up into the air. Remember, your audience has to hear every single word.

**1.** What is this monologue about?
**2.** What was your moment before?
**3.** Describe where you are—sounds, smells, and so on.
**4.** What do you want? How are you going to get it? (see pages 16-17)
**5.** Describe the dentist in detail. How is he acting as you are talking?
**6.** Who is Sheryl? What is your relationship with her?
**7.** Have you been to the Bensleys' house? Describe it.
**7.** Describe your bathroom where you brush your teeth. How close is it to your bedroom?
**8.** Do *you* hate brushing your teeth? Why? Really think about it.
**9.** What do you think Dr. Bensley's response will be? What will he tell you?
**10.** Describe your last dentist appointment. Think very hard, and give us details about it.
**11.** Are there any more questions that you can ask yourself?
**12.** Write an autobiography for this character. Build your character a life.
**13.** Remember the magic "if": What would *you* do if you were in this situation?

Write out all of your answers. Be specific. It will get you closer to the truth of the scene, and you will create a stronger character.

# THE SWAMP

We do this thing. We call it an initiation, but it really isn't. It's just stupid. We're not a gang or anything. I mean, we do this weird (*make a funny sign with your fingers*), but it's just for fun. We're just joking …

So, these guys I go to school with, we are trying come up with cool names for each other, so Augh—I mean, Dale Brown—has an idea. We'll meet at Elk Swamp at night … This is going to sound so ridiculous … One by one we have to stand in the swamp. The person has to close their eyes while the rest of us throw stuff at them. The first sound they make, that's their name. So, Jamel Richards is Ewwp. And Dana Barr is Caw-Caw. It was so funny. Ewwp threw swamp scum, and it went right in Caw-Caw's mouth, so she kind of choked on it … anyways, um, Peter Jacobs is Yourd. He actually said, "You're dead," but we shortened it. And Vinny Battulli is Puke. Because he puked. Devon Long … What an idiot. I hit him right in the face with a frog, and he yells, "Thor!" We all stop and stare at him, like, you can't do that! And he looks at us and says, "Wha?" So Devon Long is Wha. He's lucky he's not Frog Face.

And I'm Blarf. It's really lame, I know. I freaked out because some frog eggs went in my mouth. And I went to yell and barf at the same time. They said it sounded like, "Blarf." I was like, "No way!" So … that's it. We aren't a gang. We're just … a bunch of dorks, really.

**CHALLENGE:** You need to have very clear images, or your audience will not understand everything you are saying. Do not go too fast. You need to be cool, but you are also innocent—but not *too* innocent. It is a fine line. Pay close attention to your punctuation. Pause when the writing calls for it, and use your pauses to visualize. Also, make sure all the sounds sound like what happened. For example, "Caw-Caw," although it may be the sound that a crow makes, in this case is someone choking. Figure the sounds out. Tread carefully, but go for it! It ca be very challenging and fun.

**1.** What is this monologue about?
**2.** Who are you talking to? This is a very important question. Is it the police? A friend or relative from out of town? A priest? Hint: You say, "These guys I go to school with," so the person you are speaking to must not know them, right? Have a very clear picture of who you are talking to, because you are reacting to their reactions.
**3.** What was your moment before?
**4.** Where are you?
**5.** What do you want? How are you going to get it? (see pages 16-17)
**6.** Describe every one of your friends.
**7.** What kind of mischief do you guys get into?
**8.** What excuse do you use to go to the swamp at night?
**9.** Draw a picture of the swamp and its surroundings.

**10.** Where do you guys go right after you name someone?

**11.** Are there any more questions that you can ask yourself?

**12.** Write an autobiography for this character. Build your character a life.

**13.** Remember the magic "if": What would *you* do if you were in this situation?

Write out all of your answers. Be specific. It will get you closer to the truth of the scene, and you will create a stronger character.

# Longer Monologues for **Girls**

LMs

# Baseball Tryouts

This kid says, "Hey girly. You shouldn't be playing baseball. You should be home playing with your dolls." I just looked at him. I didn't say anything. It's only tryouts, for heaven's sake. So then he says something to his friend, and they both laugh. I just ... I couldn't even look at them. Then we have to bat.

The first kid, the one who called me girly, gets up, and he just whacks it. He kinda glances over at me with this weird look on his face. Then he hit another one. He missed a couple, too. But he was pretty good. He clobbered it.

Then I got up. He yells, "Good luck, girly! Maybe you can hit it all the way to your doll's house." The other boy just laughs. He's on deck, the other kid, and he says, "Hurry up so a boy can show you how it's done." I just look over at them. Then I see my mom behind the backstop, and she is sitting there quietly, just smiling at me. I smiled at her. So I step in, and the coach—the coach was pitching—he throws it. First pitch, right over the fence! It was incredible! Everybody cheered, and my mom was clapping so hard. I hit every one he pitched. The coach was smiling at me and at my mom ...

Anyways, me and the strong kid, Mike, we made the team. His friend, the one who said to hurry up so ... Yeah, he was crying because he didn't make it. I felt really bad for him. For about one minute.

{ **CHALLENGE:** To try not to brag too much. You are very proud of yourself. You let your bat do your talking. Be humble and proud. That can be tricky. You also have to talk like two different boys, so you have to change your voice. Make sure your audience can understand every word. Be proud and humble! That is a wonderful combination. }

**1.** What is this monologue about?
**2.** Who are you talking to?
**3.** Where are you?
**4.** What was your moment before? What happened just before you began to speak?
**5.** What do you want? How are you going to get it? (see pages 16-17)
**6.** Describe Mike and his friend.
**7.** Describe the coach. How did he announce who made the team?
**8.** How did you get so good at baseball?
**9.** Describe the field, the backstop, and where your mother was sitting. Have the field completely drawn in your mind.
**10.** Who else is on the team? Are there any other girls?
**11.** What did you mean when you said that you felt bad for about one minute?
**12.** Are there any more questions that you can ask yourself?
**13.** Write an autobiography for this character. Build your character a life.
**14.** Remember the magic "if": What would *you* do if you were in this situation?

Write out all of your answers. Be specific. It will get you closer to the truth of the scene, and you will create a stronger character.

# The Tick

It was huge! I swear, this tick was like (*show the size with your fingers*) … this big! I didn't even know it was on me. I was watching television, and my mom came in with some popcorn and I ran to her because I knew my brother would grab the whole bowl, and when I got to my mom, she said, "Sweetie, did you draw a mole on your neck?" I was like, "You mean a *mole* mole, like a mole that digs in the ground?" And she says, "No, I mean like a mole that you …" and she throws the popcorn straight up in the air and screams! "Oh my gosh! Darren! Angie has a giant tick on her neck!" I was totally freaking out. I was like, "Where, where?" Then she says, "Just calm down, honey." Calm down? *Me* calm down? She was going bananas and telling *me* to calm down! Then my dad comes in and walks right over to me without a word. My mom was like, "It's right there on her neck." He looks at her like, "I know, I can see it." He just grabs onto it. He doesn't say a single word to me. Not, "It's okay honey," or "Just relax, sweetie." Nothing. He just pulls it off, walks to the bathroom, and flushes it down the toilet. My mom and I were just silent. The dog was walking around eating all the popcorn. Mom, like, she just … she gets up, picks the bowl up off the floor, and says, "I guess I should make some more popcorn."

**CHALLENGE:** Speed. It is very important that you get excited and speak fast, but it is more important that we hear every word. You must also change your voice for the voice of your mother. Make sure you do not give your mother a voice your audience does not like. Otherwise, you will sound disrespectful. Your audience needs to feel the silence between you and your mother so in the background they only hear the toilet flushing. This should be really fun!

**1.** What is this monologue about?
**2.** Who are you talking to?
**3.** Where are you?
**4.** What is your moment before? What were you watching on TV? Be specific.
**5.** What do you want? How are you going to get it? (see pages 16-17)
**6.** How do you really feel about ticks?
**7.** Draw the tick. Describe it in detail. If you do not know what a tick looks like, look it up!
**8.** Describe the room that you are watching TV in.
**9.** Describe your mother vividly. What is she wearing? What does her hair look like? Tell us a story about your mother when she wasn't frantic. Then act out your mother's hysteria.
**10.** Describe your father. What was he wearing? Where was he?
**11.** Are there any more questions that you can ask yourself?
**12.** Write an autobiography for this character. Build your character a life.
**13.** Remember the magic "if": What would *you* do if you were in this situation?

Write out all of your answers. Be specific. It will get you closer to the truth of the scene, and you will create a stronger character.

# Longer Monologues for **Boys**

LMs

# COFFEE

(*Pointing*) I usually go down Booker Street and pass the gas station then up the hill by Buffoons Tavern and then take the overpass to get here. You know, the way most people go. But today I decided to mix it up so I took a right at Trenton off Booker and crossed Heinz Field. Oh—I saw this gross magazine by the bleachers! I'll tell you about that in a minute. Then I came by Get Your Buzz On, you know, that coffee shop right there? Well, Terry Emery was in line and she waved to me. You know her? Julie Jacobs's friend? She's so cute. So I went in. I've never been in there. I hate coffee. She says, "Hi, Chilly." She calls me that because when I was in gym class once, I ... Never mind. She goes, "Hi, Chilly," with her Southern accent, "I didn't know you liked coffee. You want a big buzz or a little buzz? Let me get it for you." I didn't know what to say, and "big buzz" just came out. "Room for cream?" she says. I'm like, "Sure." So I'm trying not to look like I don't know what I'm doing, so I just watch her, right? She dumps like six sugars into hers, so I dump six sugars in mine. Then she puts cream in hers, so I go to do it and I'm trying to figure out how to pour it, and she has to take it and do it for me. I felt like a total dork. But she just smiled, so I guess guys just can't figure out the creamers very easily. So we walk up the hill and come in by the auditorium, but of course the doors are locked so we had to come all the way around the school to the front, so by then I'm almost late so I just drank it down as fast as I could and Terry says I can get her a cup tomorrow and I run to class and here I am. Dude, have you ever drank coffee?

**CHALLENGE:** Speed. Talk fast and still make sure your audience hears every word. Very rarely will you be encouraged to talk fast, but this is the time. If you already talk fast, then this may be very difficult for you because you have to annunciate. Fast talkers often don't form their words completely. This character is not normally a fast talker but is talking fast because of the coffee. And you have to talk in a Southern girl voice when imitating Terry. You must change your speed when talking like her. Allow your audience to follow you, and you will be successful.

**1.** What is this monologue about?
**2.** Who are you talking to?
**3.** Where are you right now? Be specific.
**4.** What was your moment before?
**5.** What do you want? How are you going to get it? (see pages 16-17)
**6.** Draw a map of the route you took. Make sure it shows the way you usually go, too.
**7.** Describe Terry Emery. Why would someone know Judy Jacobs and not her?
**8.** Describe the coffee shop. Be specific.
**9.** What did you and Terry talk about on your way to school?
**10.** Will you go and meet Terry for coffee tomorrow? Do you have money?

**11.** Are there any more questions that you can ask yourself?

**12.** Write an autobiography for this character. Build your character a life.

**13.** Remember the magic "if": What would *you* do if you were in this situation?

Write out all of your answers. Be specific. It will get you closer to the truth of the scene, and you will create a stronger character.

# DRAMARAMA

I *do* want to go with you guys. I think it sounds awesome. Last time we went there, Tyler broke his foot. That was so cool. But I can't. I … can't. I signed up for Dramarama, and they expect me to have everything memorized by tomorrow. And I have a really cool part. I'm Sir Gil the Rusty Knight. You guys should see my costume. It's an armored suit—well, it's more like an aluminum foil suit, and we spread peanut butter all over it to look rusty. Then they got me this old motorcycle helmet and covered it with foil, but the director said I looked like a rusty astronaut. So we made a helmet out of cardboard and covered it with foil … and of course peanut butter to make it rusty. But the really cool thing is that I have to rescue Princess Ursula, who is actually Jennie Graves, who is actually the reason I joined stupid Dramarama in the first place. She's being held by this giant dragon, who is Mitch Slocum with a giant papier mâché dragon suit on. But, the thing is—and this really stinks—I got in this play to be with Ursula, I mean Jennie, but I only have, like, one tiny scene with her. I had more, but they changed it because Jennie is allergic to peanut butter. So now I come in, I stab Mitch with a fake sword, Jennie faints, and I drag her off stage. We were supposed to ride off on a peanut butter–covered old horse, and I was supposed to give her a kiss under the dangly plastic moon. I'm so bummed. Anyways, I hope you guys will come to Dramarama. It's gonna be really great.

**CHALLENGE:** To resist the urge to talk really fast. Even though there are some long sentences, don't rush. The humor will be there if you play it straight. Although some of the things you are saying are ridiculous, *you* do not think they are ridiculous. You talk about many things, and it is your job to make sure we take this whole journey with you. Stay calm, but don't get slow. Go for it! The words alone will make you funny.

**1.** What is this monologue about?
**2.** Who are you talking to? Describe everyone in this group.
**3.** What was your moment before?
**4.** Where are you right now as you talk to your friends?
**5.** What do you want? How are you going to get it? (see pages 16-17)
**6.** Where are your friends going? You've been there before, so describe it.
**7.** Describe how Tyler broke his foot.
**8.** What is your relationship with Jennie? Describe her.
**9.** What would happen to her if she ate peanut butter?
**10.** Who is the director? What are your feelings about the director? Do you like the play?
**11.** Are there any more questions that you can ask yourself?
**12.** Write an autobiography for this character. Build your character a life.
**13.** Remember the magic "if": What would *you* do if you were in this situation?

Write out all of your answers. Be specific. It will get you closer to the truth of the scene, and you will create a stronger character.

# Monkeyman

We call it treein'. It's amazing. There are all these pine trees, and they're all planted right in a row. There's rows and rows of them. They make, like, this forest, right? We go into this forest, and we go treein'. What we do is we climb these trees and get way up to the top. And once you get way up there, the branches all start getting smaller and smaller. Like a tree. You can't see anything up there because all the trees are the same size. Well, once you climb as high as you can, the whole tree starts to really bend. It is so awesome. You have to really hold on, and it feels like the tree is just going to snap … It did actually snap on my friend Chase, and he fell all the way to the ground. But here's the thing: The pine needles make the ground really soft. Chase is chubby, and he just bounced. Unbelievable. He still cried, but he wasn't really hurt. He just always cries.

So, when you get high enough for the trees to bend, you creep out onto a branch as far as you can. Then the tree bends, and you jump to the next tree. Now the next tree, because it's the same size, bends too, and you can jump to the next one. It's awesome! You can sneak across the whole forest without ever being seen and without ever going down to the ground.

My father would kill me if he knew we were treein'. He already warned me once. He's afraid I'll break my neck. I won't, though. I'm like Spiderman up there. Or Monkeyman … Is Monkeyman somebody? Should be. A big M on his shirt. With hairy knuckles and gnarly teeth. Come over. You could be Spiderman, and I'll be Monkeyman.

**CHALLENGE:** Nobody will know what treein' is, so you have to carefully paint a picture for your audience. When you tell a story to someone and you know all the details but they don't know anything about it, you have to really use your body, your hands, and your voice to make them see what you are talking about. Do NOT rush! Your thoughts jump around, too, so carefully craft your monologue. And have fun!

**1.** What is this monologue about?
**2.** Who are you talking to?
**3.** Where are you?
**4.** What was your moment before?
**5.** What do you want? How are you going to get it? (see pages 16-17)
**6.** How do you get to this forest? Where is it, exactly?
**7.** How did you act when Chase fell? Were you scared? Was it funny? Describe the incident.
**8.** How did your father warn you before? How did he know you were treein'? Did you tell him? Did he catch you?
**9.** How did you first discover treein'?

CONTINUES ▶

**10.** Draw Monkeyman.

**11.** Are there any more questions that you can ask yourself?

**12.** Write an autobiography for this character. Build your character a life.

**13.** Remember the magic "if": What would *you* do if you were in this situation?

Write out all of your answers. Be specific. It will get you closer to the truth of the scene, and you will create a stronger character.

# The Bat

It wasn't the first thing I did! I didn't go over there and say, "Oh hi, Steven. I have friends coming over, and you aren't one of them." I went over there to ask him if he was done using the Bombs Away bat that we *both* bought. It's half mine. I should be able to use it.

You should see this bat. This bat is unbelievable! I hit three balls in a row over the fence. Right over Steven's head, unfortunately. I think he might have been crying when I hit the third one, because he just pulled his hat down and never even turned around to see where it went ...

I think what happened was he thought that, because we bought the bat together, that I would choose him on my team. But I couldn't! I had a chance to choose Evan and Corey and Rondo. They are ten times better than Steven. Maybe I could have chosen him over Rita. Maybe that's what he was so mad about. But she is so cute. And I actually think she might be better than Steven. And I chose Abigail, of course, because she is just a bruiser. She's awesome. I even chose her before Corey. And she hit a home run right over Steven's head too. He ran after it and sort of acted like he ran into the fence really hard and hurt his ankle. It looked fake.

And then to make it worse, I struck him out twice. He begged me the last time to let him hit it, so I just tossed a really easy one to him and he popped out. To *me!* Then he throws the bat and says it's the worst bat ever ... So anyway, I went to borrow it, and he called me a lousy friend and a backstabber and a show off, and he slammed the door really, *really* hard. Why are you looking at me like that? It's *my* bat!

**CHALLENGE:** To make whomever you are talking to understand your point without you sounding like an insensitive kid. You need to make your audience see Steven the way you see Steven and not as someone we feel sorry for. Your audience will feel for him anyway, but it is your job not to sound like a total jerk. Convince us you did nothing wrong, and have fun!

**1.** What is this monologue really about?
**2.** Who are you talking to? Try it talking to an adult—Mom or Dad, maybe. Then try it talking to a friend. Decide which you like more.
**3.** What was your moment before?
**4.** Where are you?
**5.** What do you want? How are you going to get it? (see pages 16-17)
**6.** Describe all the people you chose over Steven. Your audience will especially like to see what Abigail looks like.
**7.** Describe the baseball field and the fence behind Steven. Are there signs on it? Is it wooden?

CONTINUES ▶

**8.** Describe Steven. Be very specific.

**9.** How did it happen that you both bought the bat?

**10.** Why do you think Steven was faking it when he hit the fence? Act it out.

**11.** Are there any more questions that you can ask yourself?

**12.** Write an autobiography for this character. Build your character a life.

**13.** Remember the magic "if": What would *you* do if you were in this situation?

Write out all of your answers. Be specific. It will get you closer to the truth of the scene, and you will create a stronger character.

# With Friends Like Me

First of all, you need to totally size up the entire situation. You can't assume anything. My mother always says that only donkeys assume. So, let's look at everything. Let's answer the big question: Why do you think she would go with you? Right? That's a good place to start. You are a total dork. No, seriously. But apparently girls like dorky guys, so it's all good. You're dorky, but you only kinda pretend you're dorky. Right? You're only … like when you went for Halloween as a "frustrated shoe" and you put shoe laces up your nose and you let everybody put big wads of gum in your hair? You already planned on shaving your head after that, right? I mean, it's kind of funny, but … and secondly, is she too pretty for you? Remember when Chubzy Bowman went to that dance with Danica, and Danica danced all night with Logan? I know Chubzy had a cast on his foot. But people talked. It doesn't look good. And third—and this is huge— are you sure, I mean, are you absolutely, positively positive she doesn't like someone else? Seriously, have you asked her? You could ask, "Is there anybody else in the class, anybody you think is funny and cute that you might wish would ask you instead?" You might be putting her in a very awkward position by asking her out. I can't imagine anything worse than being asked on a date by someone that you really, really like *as a friend* when deep down you might hope that someone else asks you instead. Have you asked her that? Maybe you should. You know, save yourself the embarrassment. That's what I would do.

**CHALLENGE:** To not be too sly. You are manipulative, but play it straight. Make your audience think that you are looking out for your friend, not trying to move in on his girl. Your friend is probably a better person than you are. How can you trick him into thinking you have thought long and hard about this and it is for his own good? Play it straight. Playing off a best friend can be tricky because he knows you better than anybody!

**1.** What is this monologue about?
**2.** Who are you talking to? Be specific. Give the person a name, a face.
**3.** What was your moment before?
**4.** What is the room like that you are in?
**5.** What do you want? How are you going to get it? (see pages 16-17)
**6.** Why didn't you ask this girl out yourself? Are you shy? Nervous?
**7.** Describe your friend in detail. Why is he your best friend?
**8.** Describe the girl in detail. Don't be shy here. Really describe her. It may reveal who your "type" is, but who cares? You're an actor!
**9.** What does the title mean?
**10.** Tell us about Chubzy, Danica, and Logan. What dance were they at? Details!

CONTINUES ▶

**11.** Are there any more questions that you can ask yourself?

**12.** Write an autobiography for this character. Build your character a life.

**13.** Remember the magic "if": What would *you* do if you were in this situation?

Write out all of your answers. Be specific. It will get you closer to the truth of the scene, and you will create a stronger character.

# Nailing the Audition
## by Lana Young

**I AM HERE TO HELP SOLVE THE MYSTERY OF THE AUDITION** (spooky music here). The good news is, casting directors *want you to be the one!* For film and TV, the casting director's job is to compile the *best* auditions on camera and hand them over to the client. *They want you to look good* so that *they* look good and, ultimately, their clients are happy. In theater, these directors want to be moved by your live performance and see that you're a team player. So go ahead and treat your relationships with casting directors as mutually beneficial partnerships. It helps if you look at your performance as a gift to your audience. Connect to the story, and if you feel it, they will feel it.

## When Will I Need a Monologue?

- Agent or manager interviews
- Auditions for classes, theater, and sometimes film
- Talent showcases
- *Always* have a monologue or two prepared

*"Luck is what happens when preparation meets opportunity."*
—Lucius Annaeus Seneca

## Monologue Selection

- Be sure to follow the casting director's (CD) or agent's instructions for what to prepare. For example, maybe they want one comedic monologue and one dramatic monologue, or only a one-minute monologue. They are very busy and don't want to waste any time. It's also more professional to be prepared.
- Choose a monologue that you connect with emotionally. CDs and agents love to be moved to laughter, anger, or tears. If you can do this, you have just established yourself as a talented and professional actor. This is the difference between an actor just reciting lines and a brilliant actor experiencing the story.

## The Acting Coach Approach

■ *Prepare, prepare, prepare!* Follow the suggestions and answer the questions in this book, and go into every audition knowing exactly who your character is, who you are talking to, where you are, what you want, and why.

■ Now let it go. Now is the time to trust yourself. You've done the work, and you've created images for yourself. It's in your body, so let it go. It will be there when you need it.

## Arriving at the Audition

■ You start your audition the moment you walk into the waiting room. That person sitting behind the desk *may* be the person who will hire you.

■ Always arrive early—the earlier, the better. This will give you time to settle in and connect with your character and any "cold read" material.

■ Sign in, hand the casting assistant your headshot, and listen for specific instructions.

■ Sit down and quietly go over your monologue (or scene), or find a location where you can practice out loud. It is great if you can find a place to say it out loud.

■ Listen for your name to be called, and be ready to go in when you hear it.

## In the Audition Room

■ The casting director is your friend. That person *wants* you to be the one.

■ Walk in with a smile and a greeting. Be aware of the room and be flexible. Some CDs like to chit-chat beforehand, and some do not. Just follow their lead.

■ Be as relaxed as possible.

■ Always be prepared to briefly talk about something in your life if they ask. You can talk about your dog, the ride over, what you had for breakfast. They just want to hear your voice.

■ There may be several people in the room (assistant, writer, producer, CD, director) or just one person. Treat everyone with respect, and be sure to *listen*.

> ### NERVES
>
> ■ Actors are nervous when they care.
>
> ■ If you are prepared, your nerves can be your friend.

■ For film/TV, the CD will ask you to *slate* your name. This is like a handshake. Look directly into the camera lens as you would into the eyes of someone you are meeting, and say, "Hello, my name is (YOUR NAME)". Listen for specific instructions, because sometimes they want you to say more information, like what role you are auditioning for or who your agent is: "Hi, my name is Lana Young, and I'm auditioning for the role

**93**

## HEADS UP!

Sometimes a monologue or a scene is handed out at the audition. This is considered a "cold read." The Acting Coach Approach works very well in this situation. Every actor is in the same boat, and the ones who prepare before they go in the audition room will stand out every time. Always be sure to have the basic Acting Coach Approach questions with you

of _____." *Practice your slate.* If it is not good, the person doing the hiring may fast-forward right through your audition. For fun, you can even add an essence of the character you are about to play.

● Now you're ready to perform your monologue (or your scene). *Do NOT audition into the camera* or directly to someone in the room *unless* they ask you to, but that is very rare. If you are unsure, you may ask. Find a spot just to the side of the camera, and make that your eye line. If you are speaking to more than one person in your monologue, then find an eye line that represents each person, and be sure to talk to all of them—just like in a real conversation. The camera wants to see your eyes. In a theater audition, find a spot above the director's head to represent the person/people you are talking to. If you are auditioning onstage, find a spot at the back of the theater. Just remember, they want to watch *you*. They do not want to be watched.

## GLOSSARY

● **CD** - casting director
● **Slate** - an introduction of yourself into the camera
● **Cold read** - when you have no advance time to prepare because monologues or sides are given out at the audition
● **Sides** - a portion of a script used for auditioning
● **Eye line** - the direction an actor is looking (this can impact the audience's emotional connection to the characters)

● Be prepared for direction. The CD may give you an adjustment. Do not be thrown. They just want to see if you can take direction and make adjustments in the moment. Be flexible, and if you are not sure what they want, *ask them to clarify.* Always ask questions if you are not sure.

● *Never apologize.* Be professional. If you make a mistake, just ask if you can start again, or make it part of your character. Don't judge yourself. The CD is trying to imagine you in the role—that is what's important here.

● When you are done, do not ask how you did. They most likely won't tell you, so do not expect it. Just say *thank you* and leave with a smile.

## GOLDEN RULE

### Be a good listener.

It's my number one rule. You've done all the work—now relax and listen.

- If you don't listen to your scene partners, then you will not know how you feel about what they are saying.

- If you do not listen in the audition waiting room, you may miss important instructions.

- If you do not listen to your director, you'll miss important information.

# After the Audition

- Think about what you just did and how you would improve on it next time. Give yourself credit for getting an audition and for all the good things you did in there. And then *let it go.*

- Some CDs call or email even if you do not get the role. However, most do not. If you do not get called or emailed, then just chalk it up to another opportunity to be seen.

- We are not all right for all roles, and there are *thousands* of reasons why we do not get cast. For example, you might sound too much like someone else who is already cast. Or maybe your hair is too short, you walk like a dancer and they need a street kid, or you are too sweet. Do not beat yourself up. It's part of the biz. Look at auditions as a chance to practice and get seen. If they like what they saw, they *will* remember you for future projects. It is their job to spot talent. So just enjoy it and accept it.

Nowadays, some auditions are video submissions. That means you can film them yourself and submit them online. Usually these come with very specific and clear instructions. However, if you do not have time to figure it out or just don't have the equipment to accomplish it, just get in touch with Hollywood Theatre Lab for a consultation, and we will help you through it: hollywoodtheatrelab@gmail.com.

*Break a leg, and have fun!*

Lana Young

## And Now for the Thank you's

Thank you Mom and Dad for continuing to believe and see things even when I can't. Thank you to the rest of my family as well, from whom the love and support never ceases. I want to thank Lana Young for her section of this book. Lana has also been instrumental in getting these monologues out of my mind and onto paper so they may be performed by her young actors at Lana Young's Hollywood Theatre Lab and The Village School, both in Charlottesville, Va. I would like to say thank you to Dayne Pratt, my editor extraordinaire (is that spelled right?) out in Flagstaff, Az. And a thank you, thank you to Ferro+Ferro Graphic Communication in Arlington, Va. for making this book much more than I could have asked for. You are awesome, Sal.

I must also give a very special thank you to Joanna Christie for endorsing my book. Joanna played alongside Daniel Radcliffe (Harry Potter) in *Equus* in London and she is presently starring as "Girl" on Broadway's *Once*. Thank you, Jo.